THE OFFICIAL COLORING BOOK

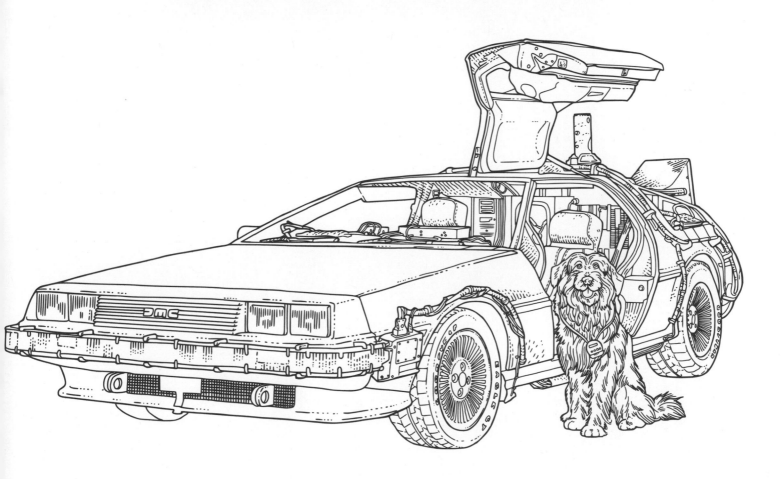

INSIGHT
EDITIONS

SAN RAFAEL · LOS ANGELES · LONDON

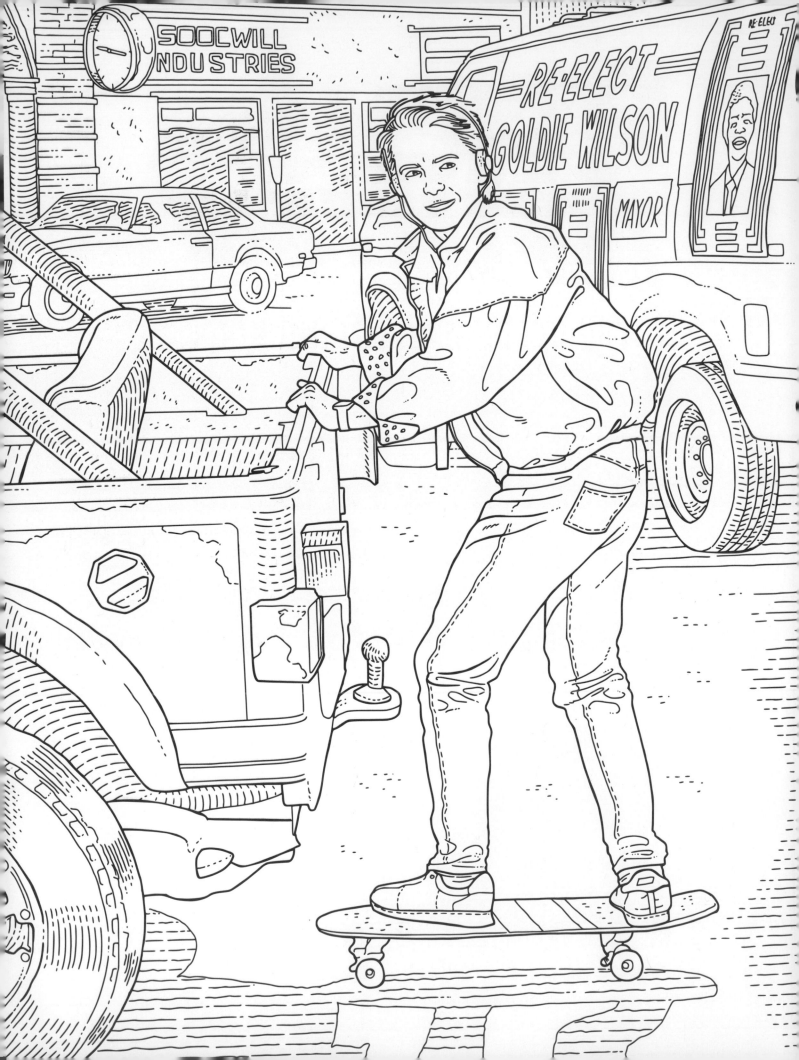

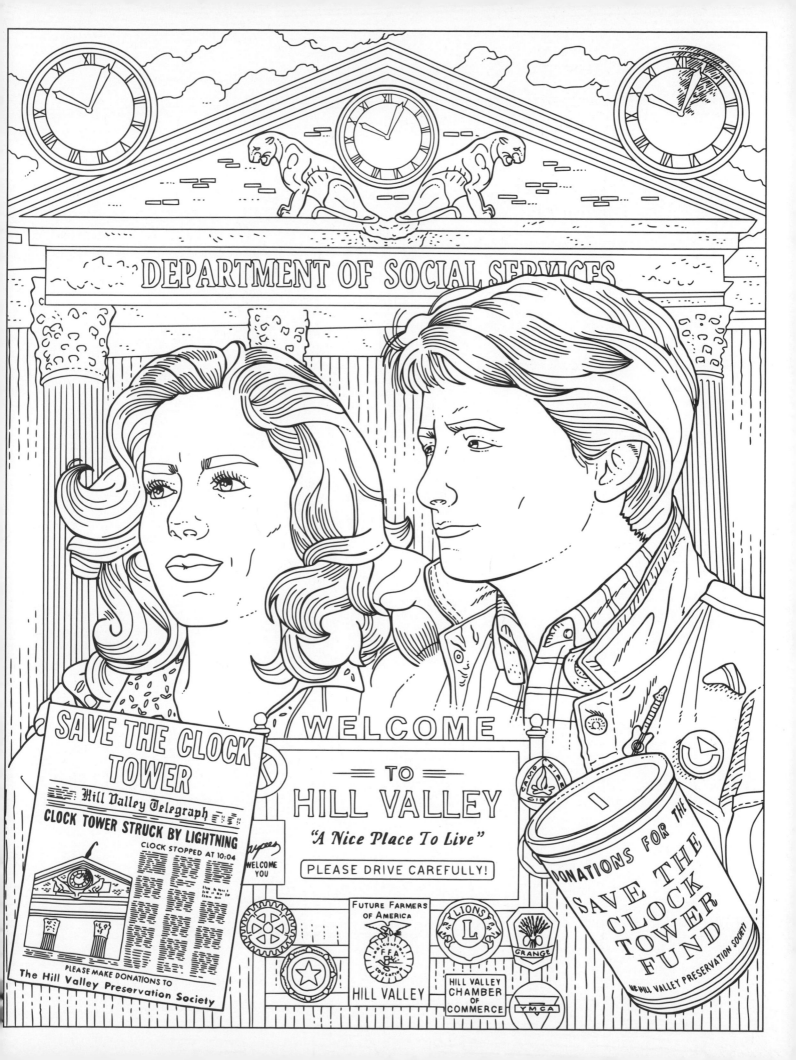

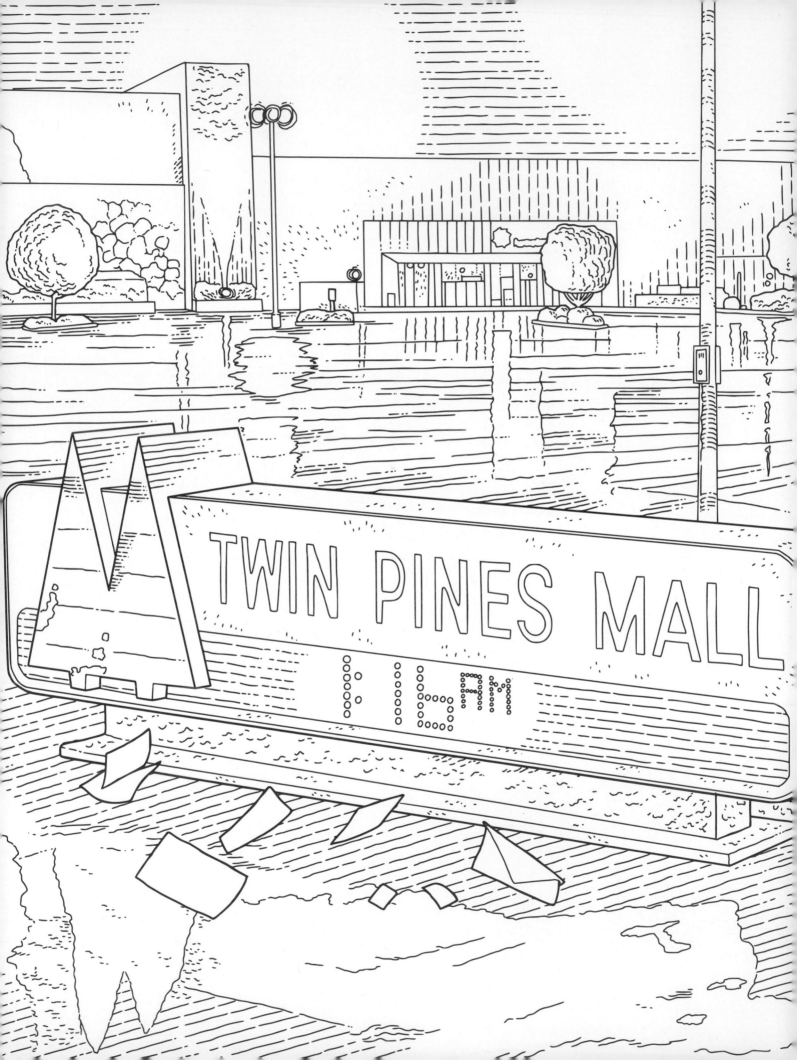

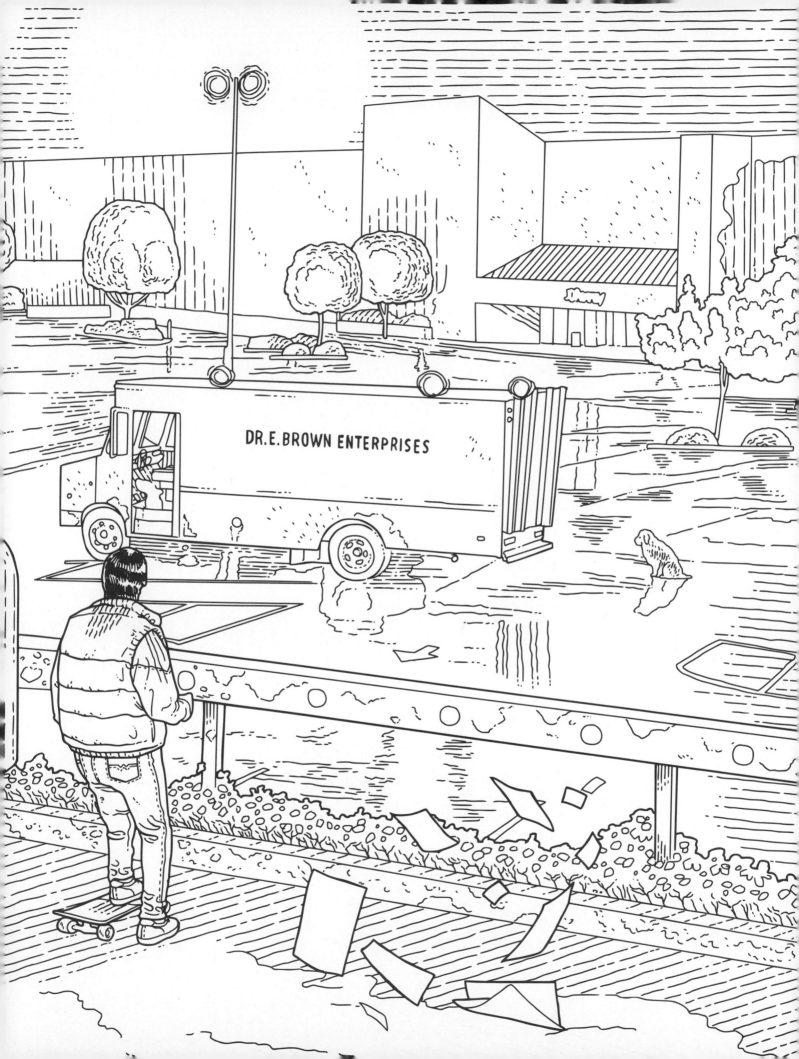

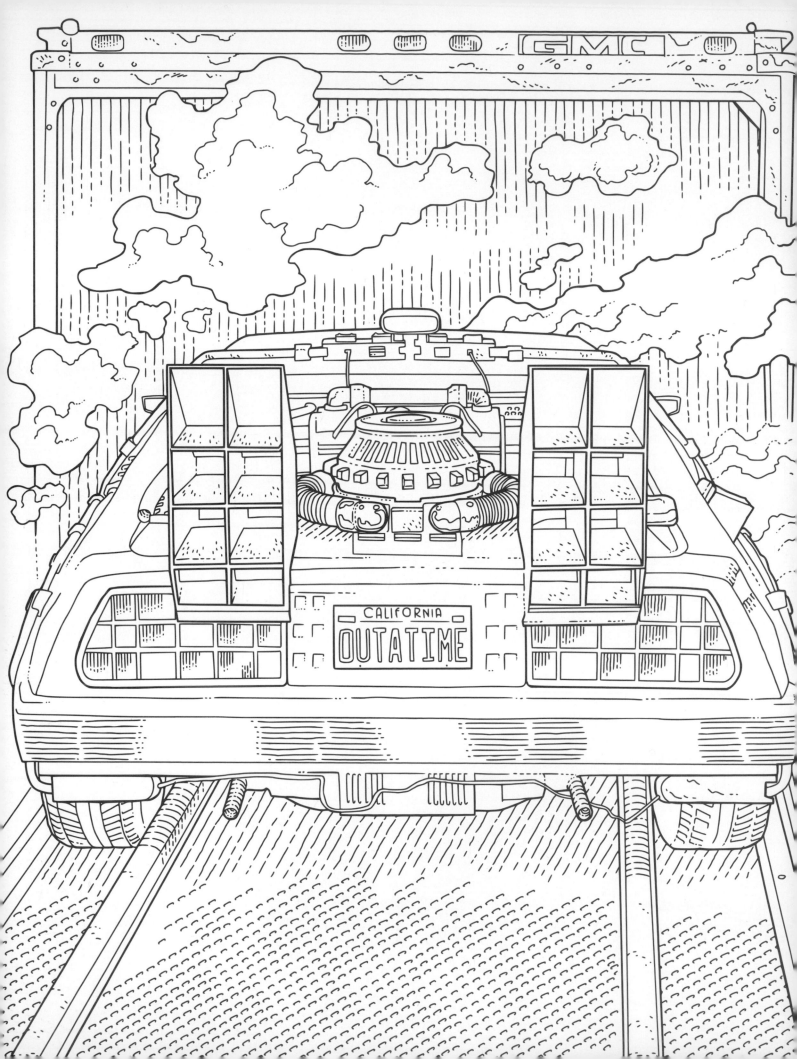

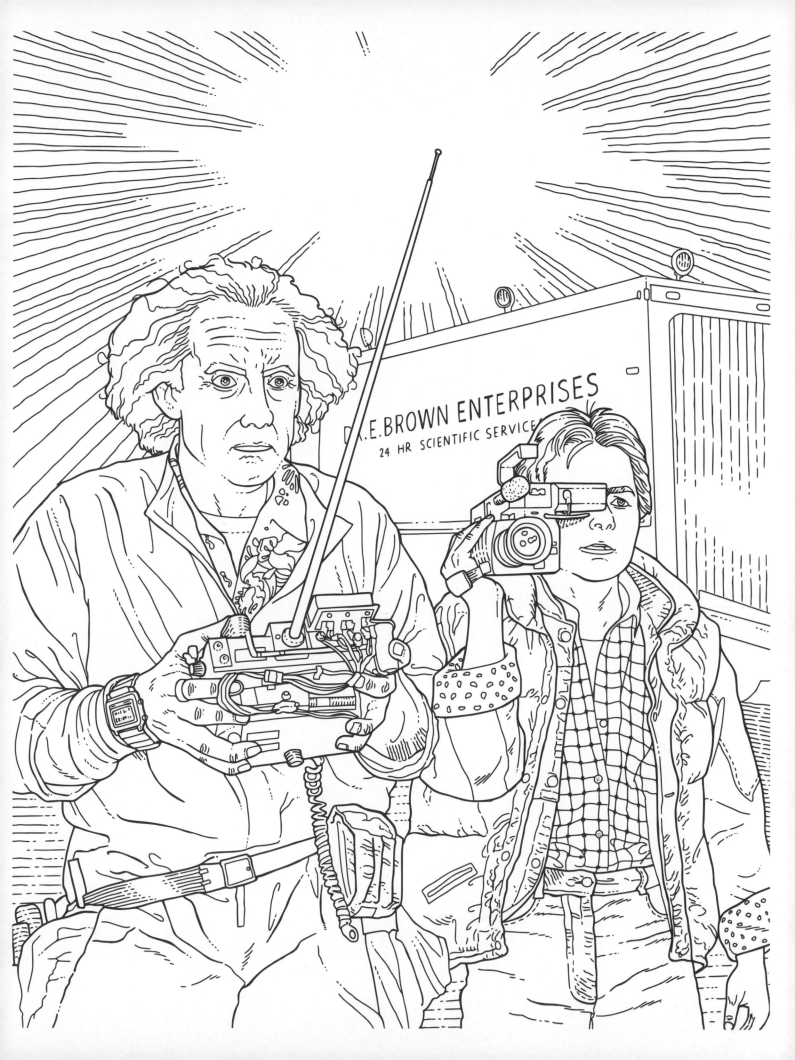

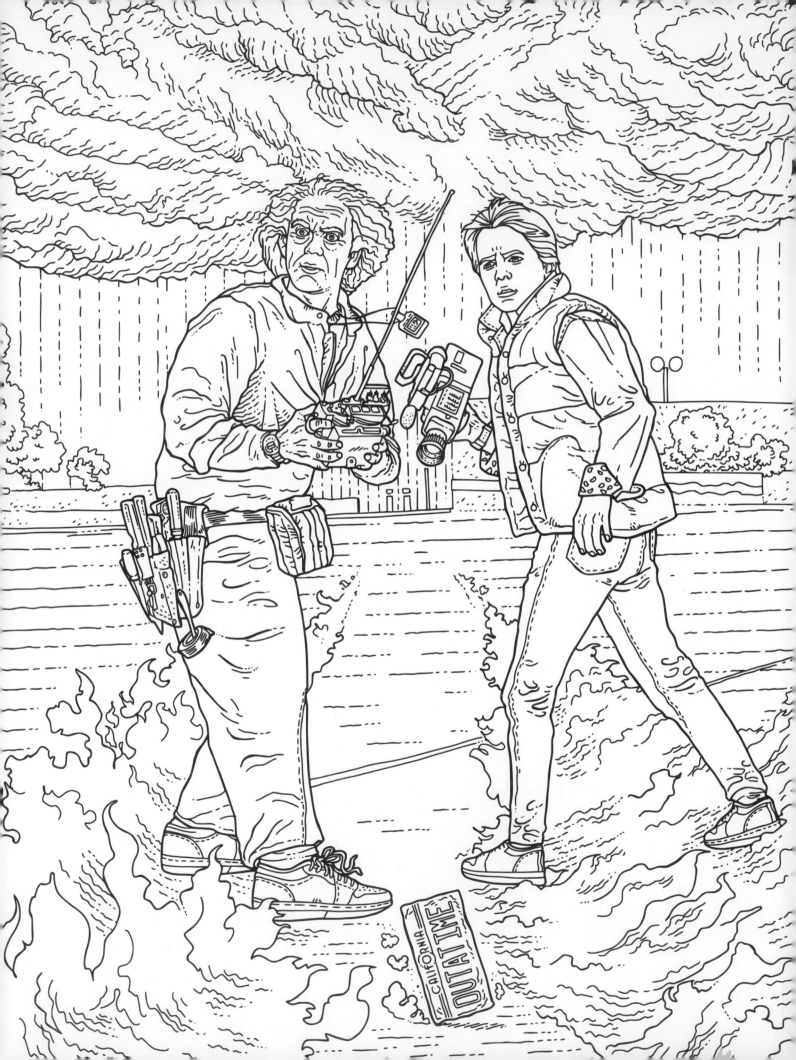

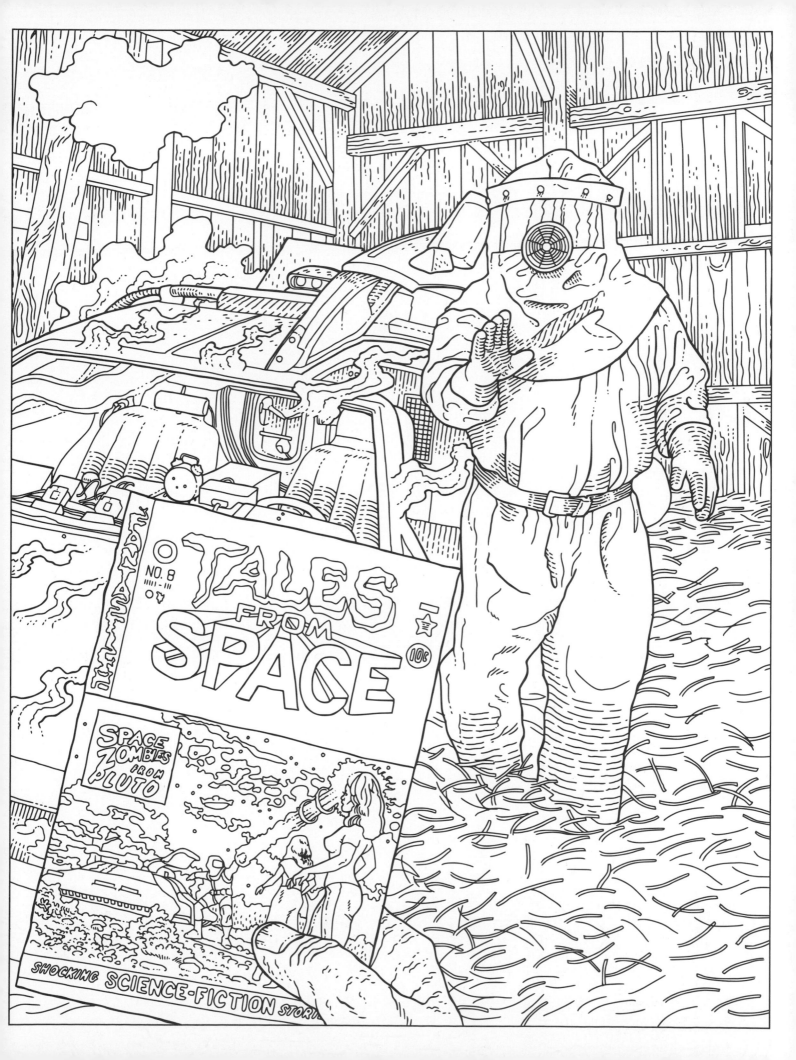

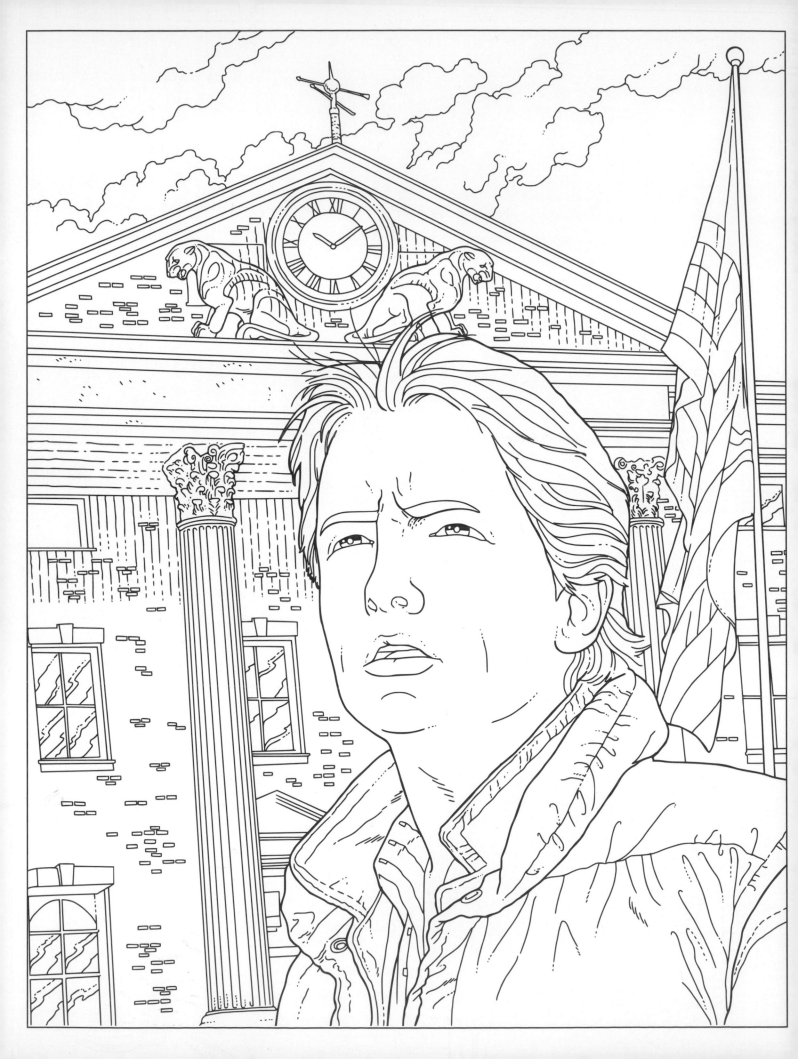

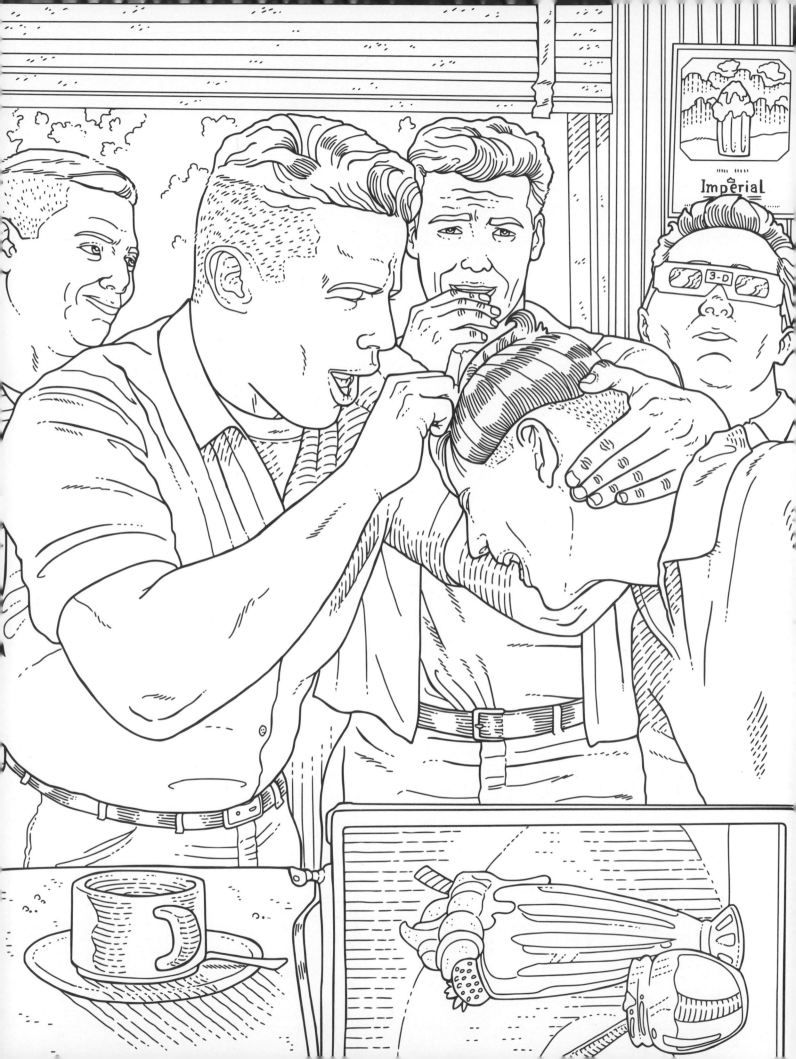

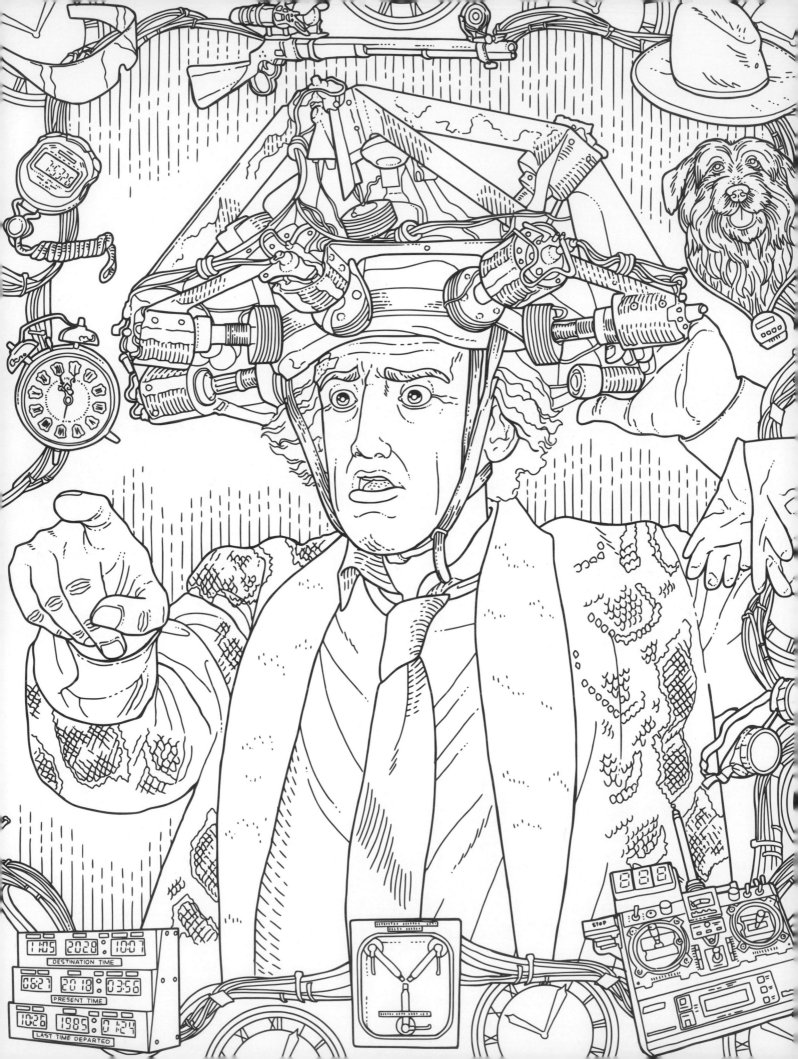

DESTINATION TIME
11:05 2020 10:07

PRESENT TIME
06:27 2018 03:58

LAST TIME DEPARTED
10:28 1985 04:24

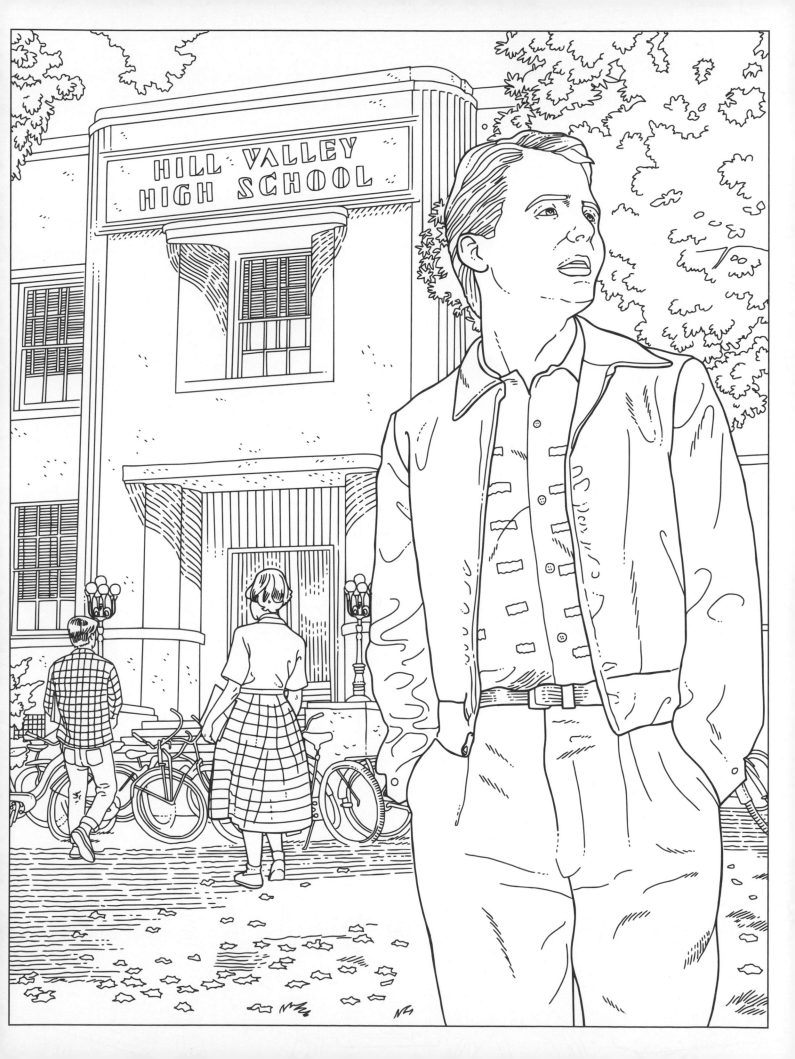

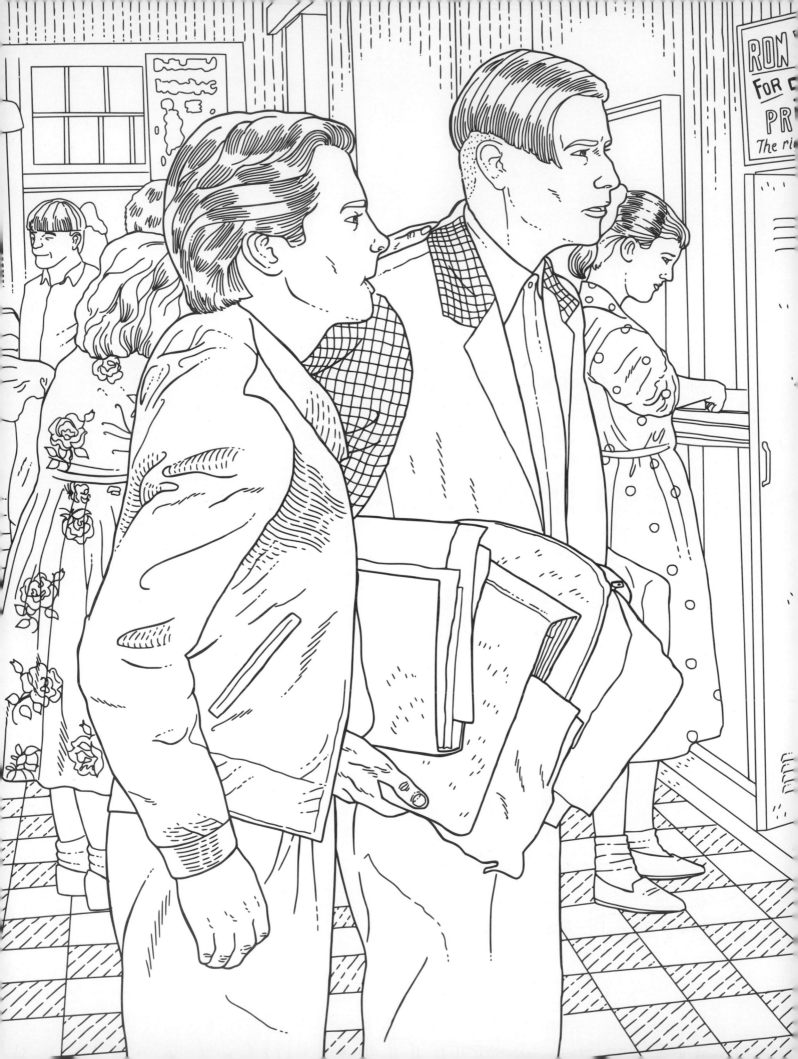

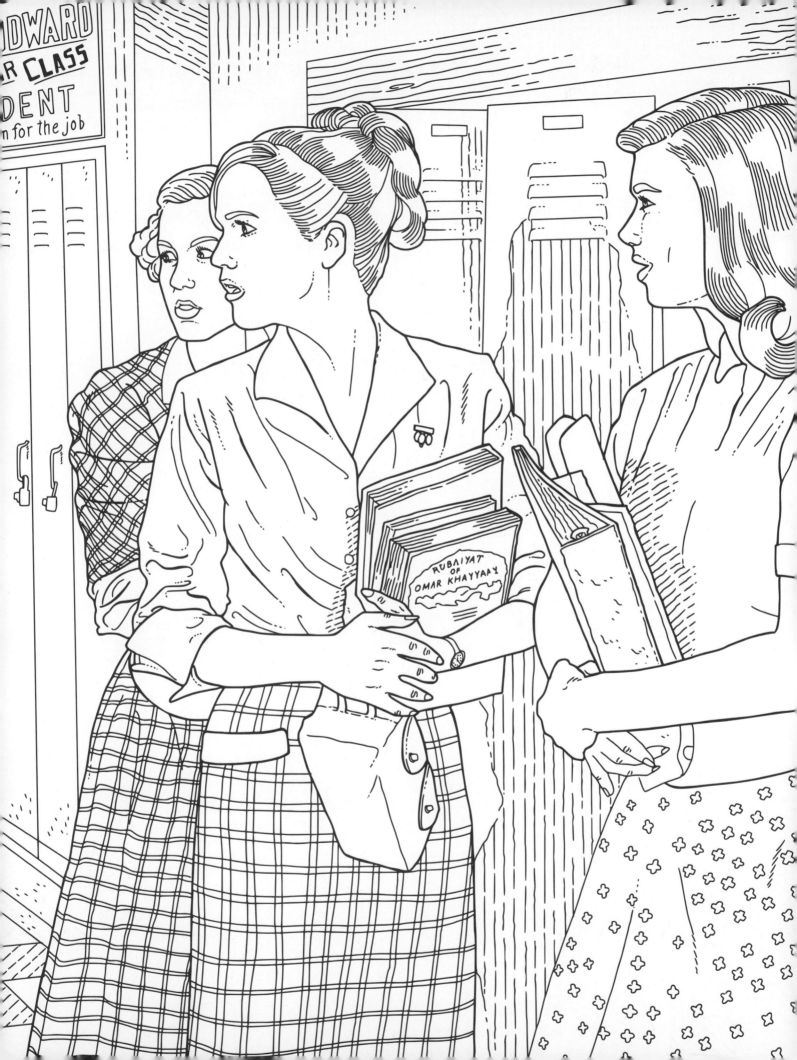

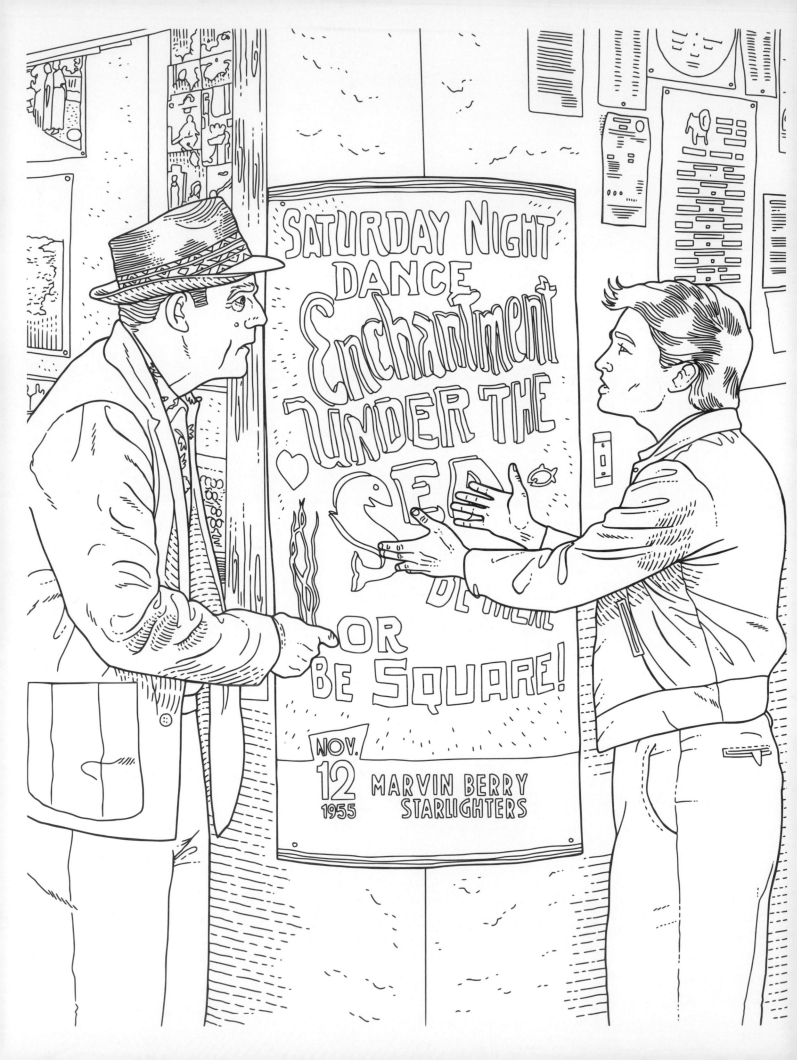

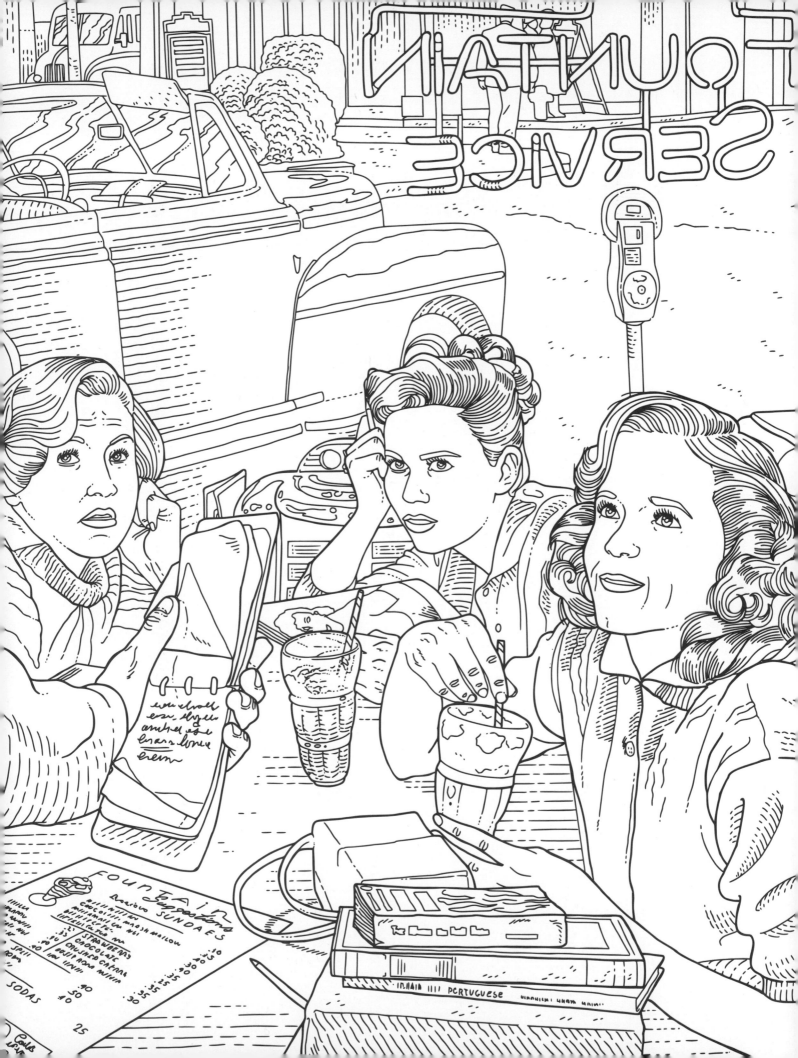

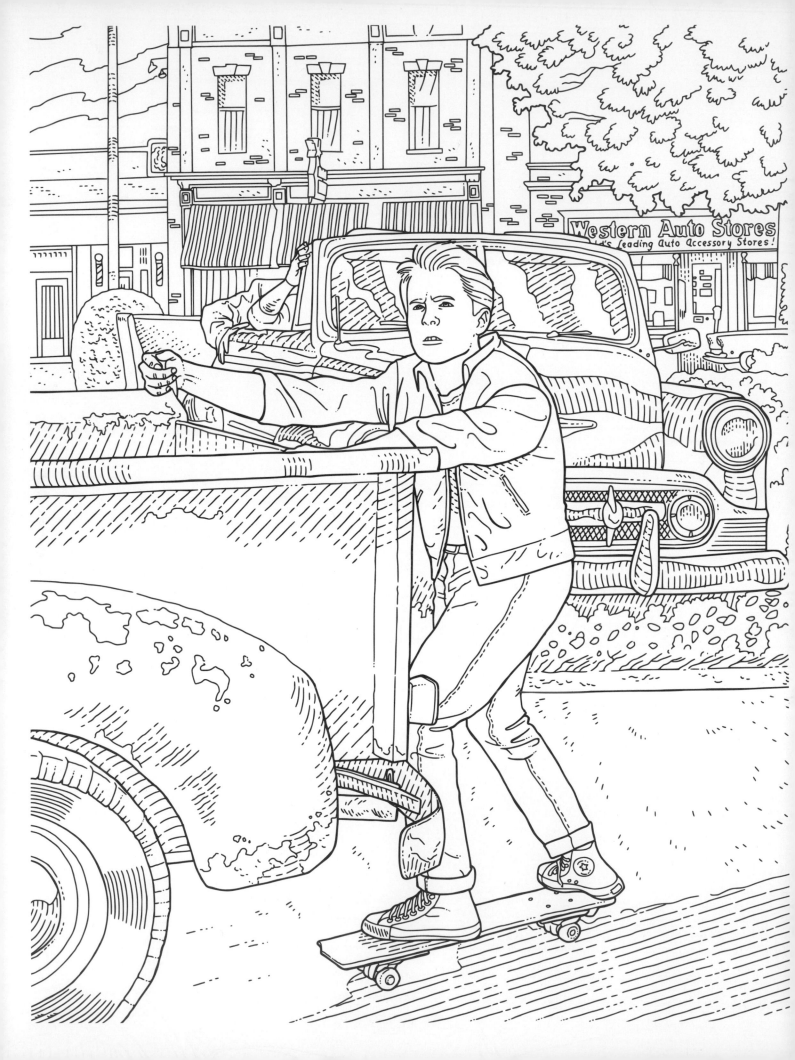

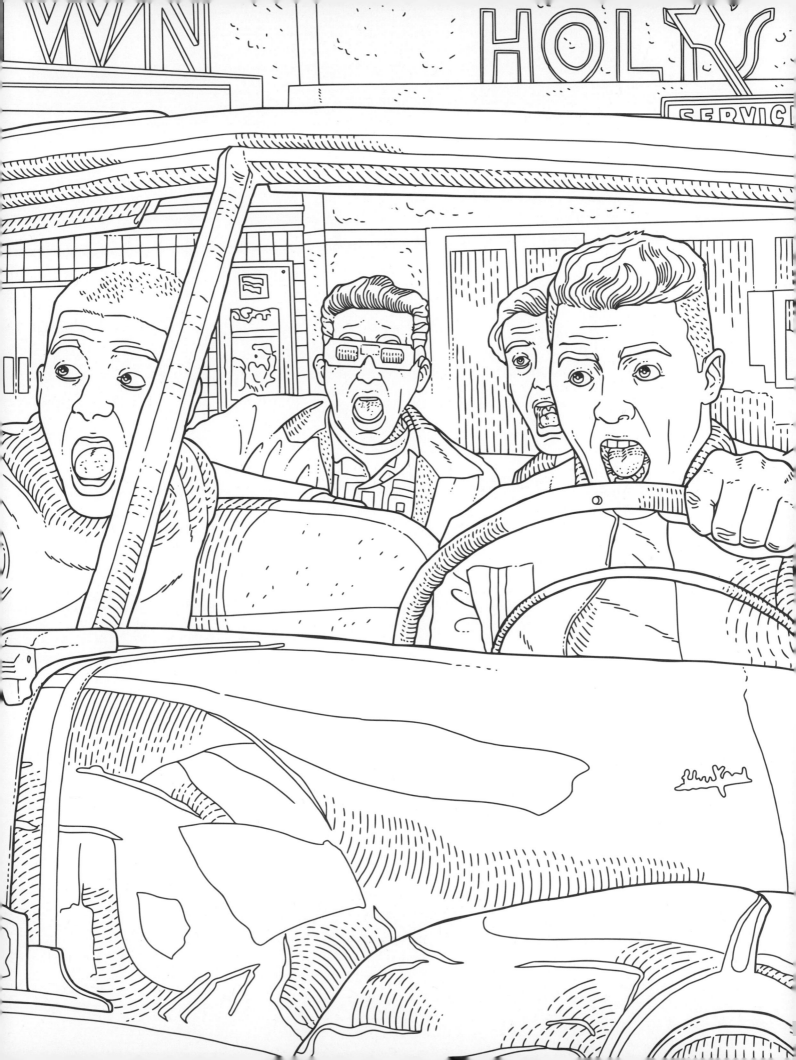

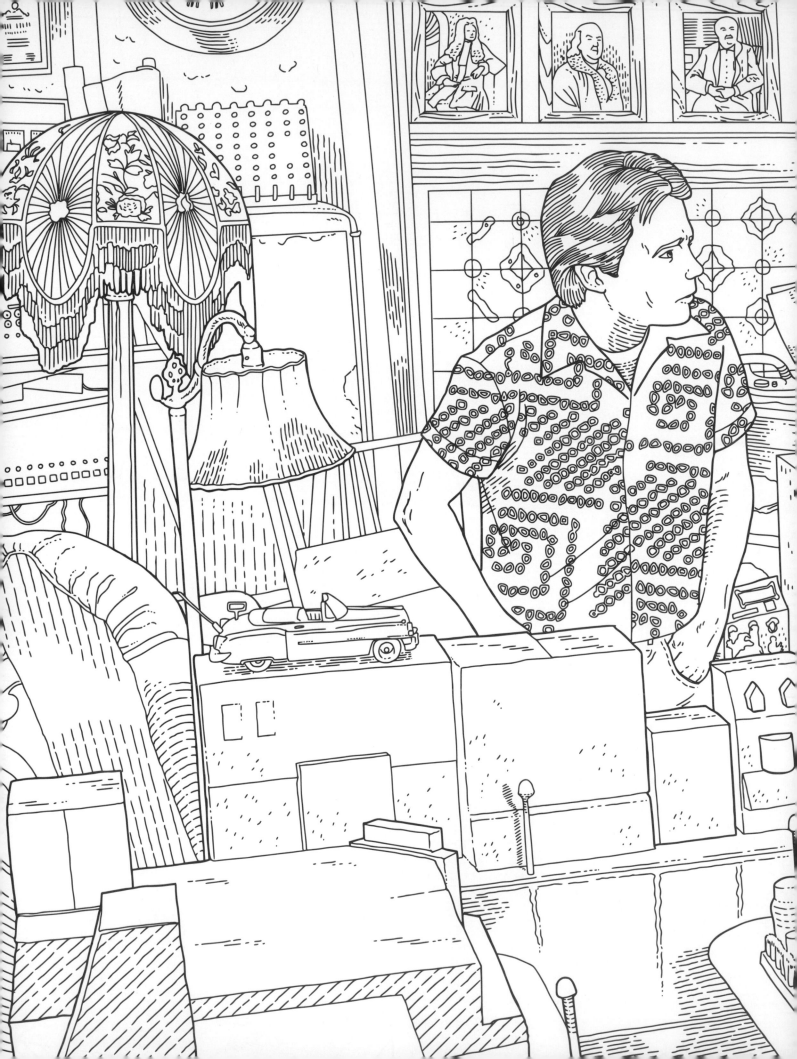

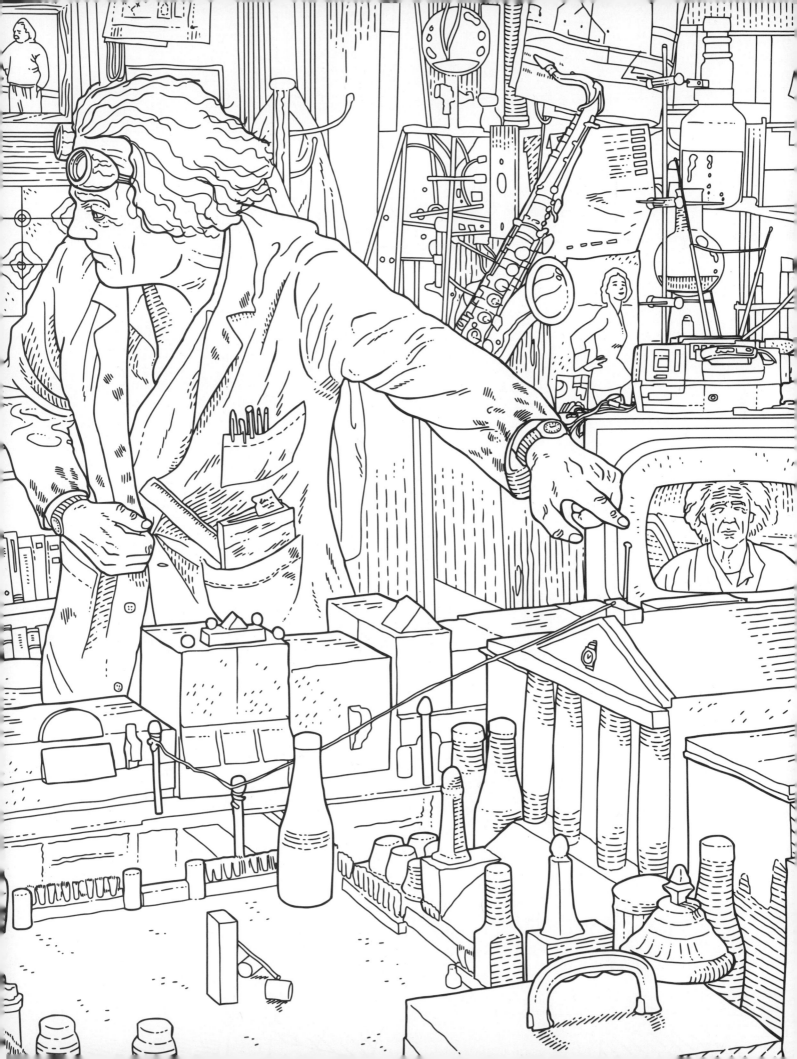

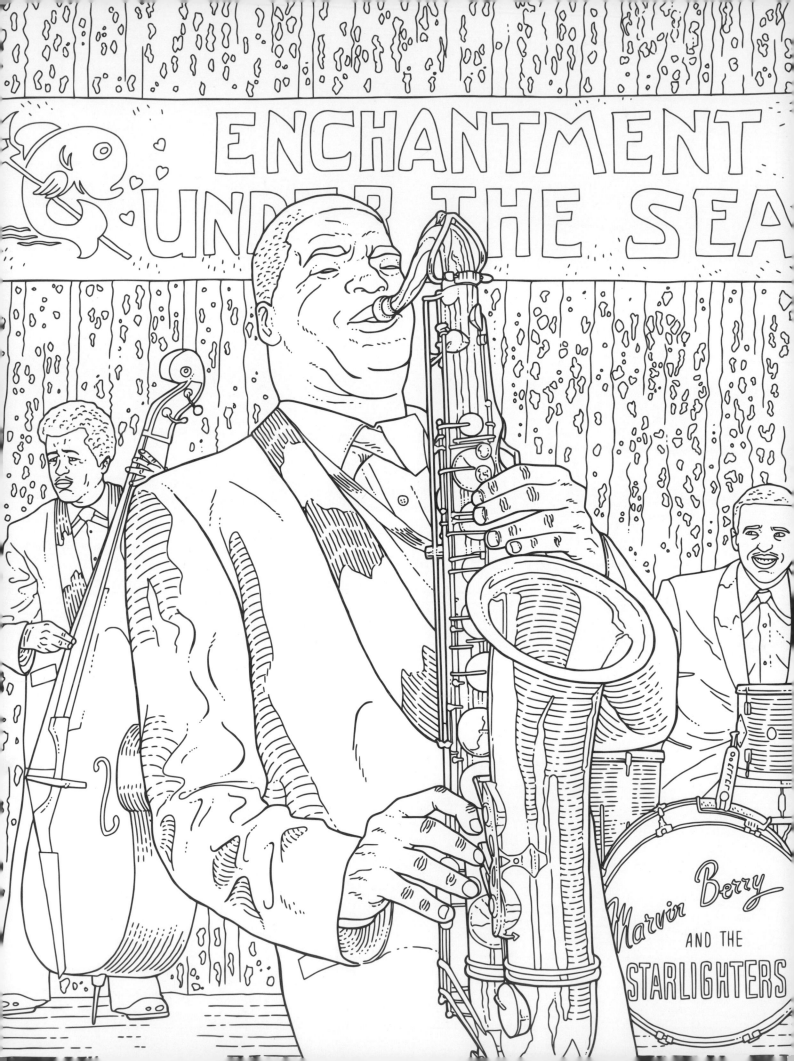

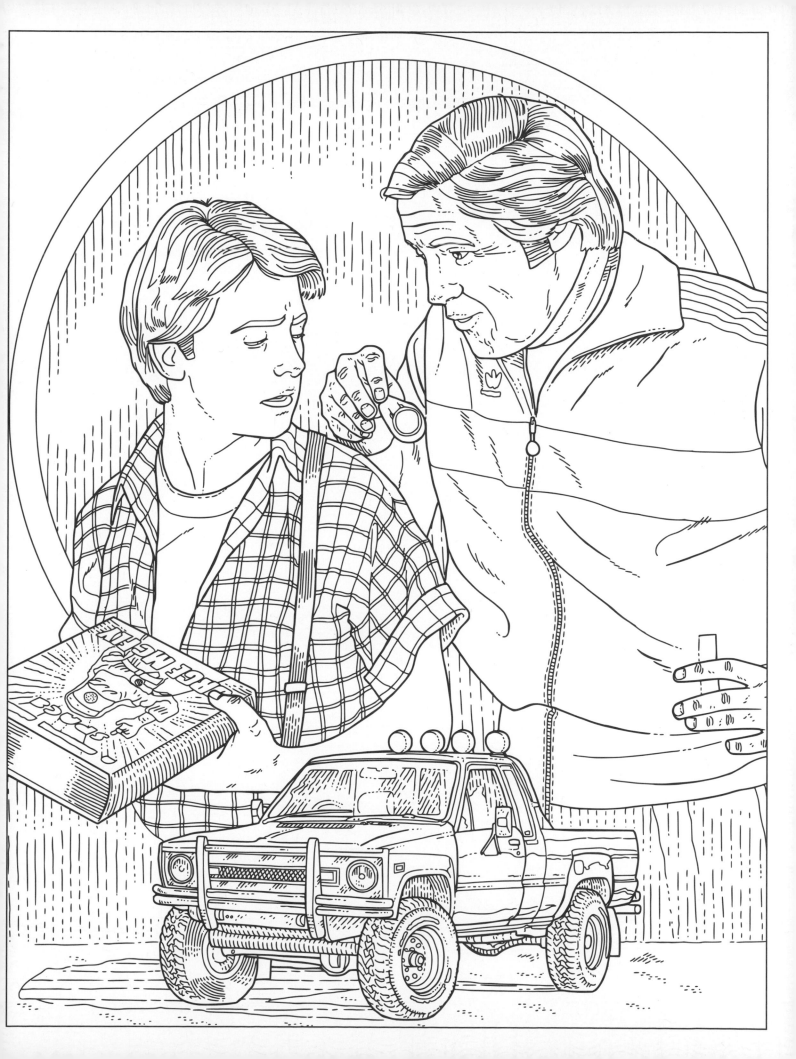

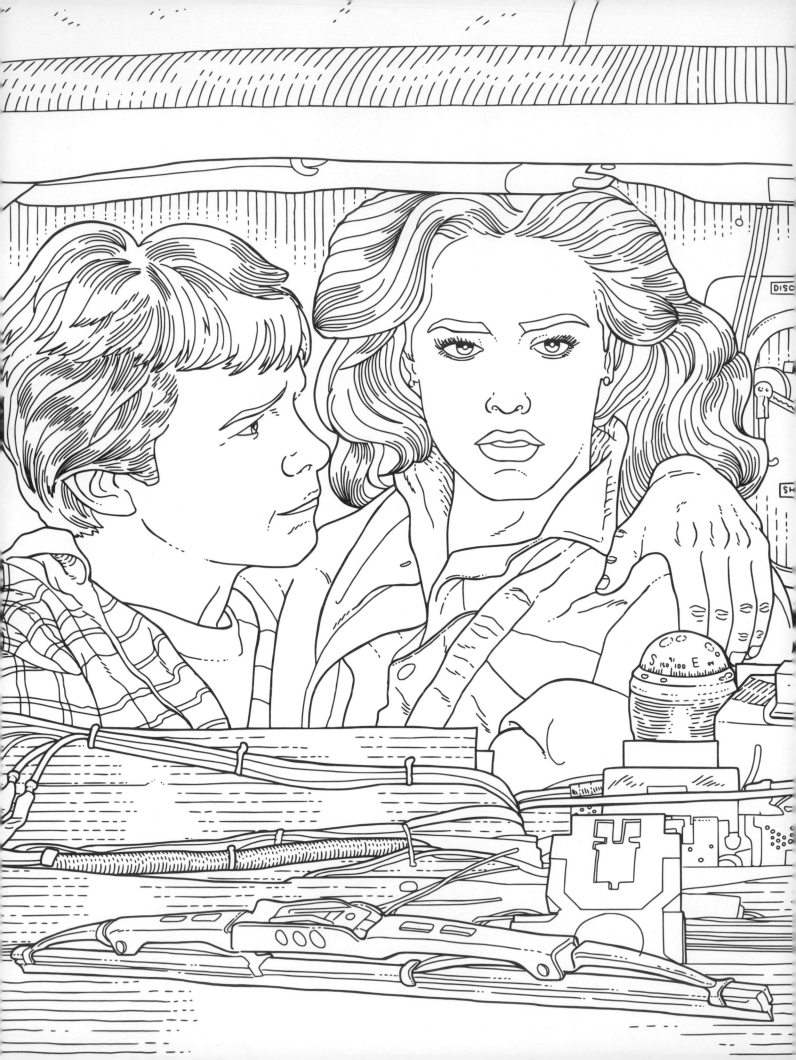

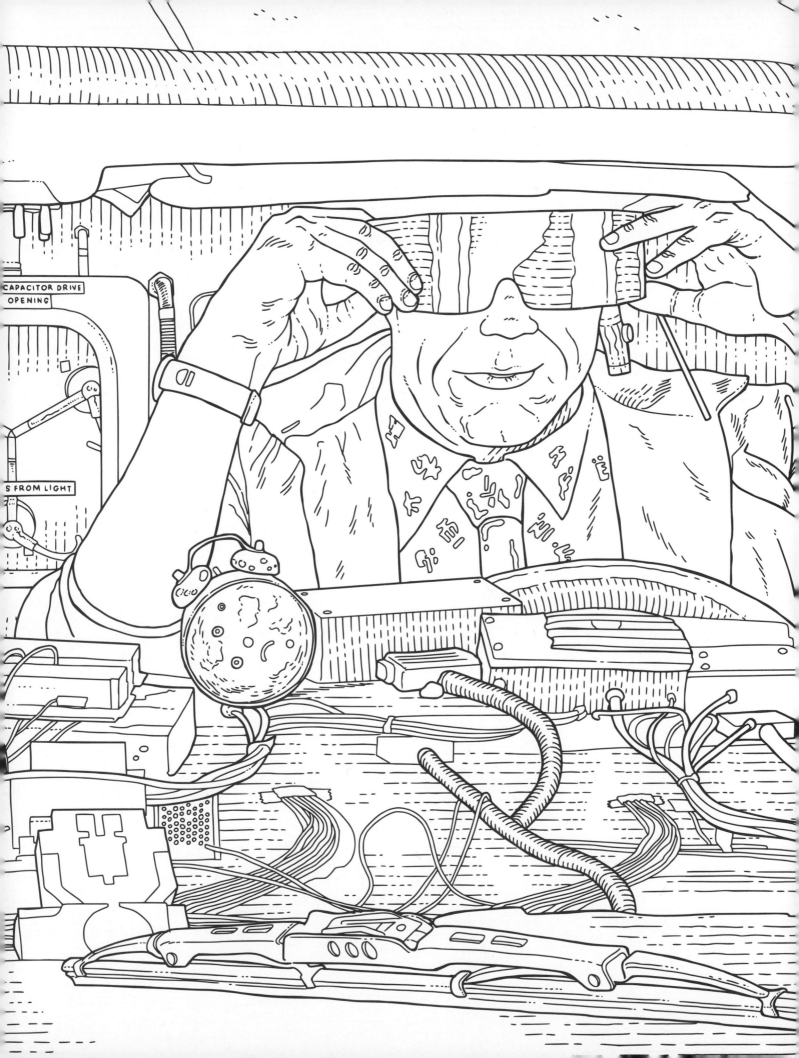

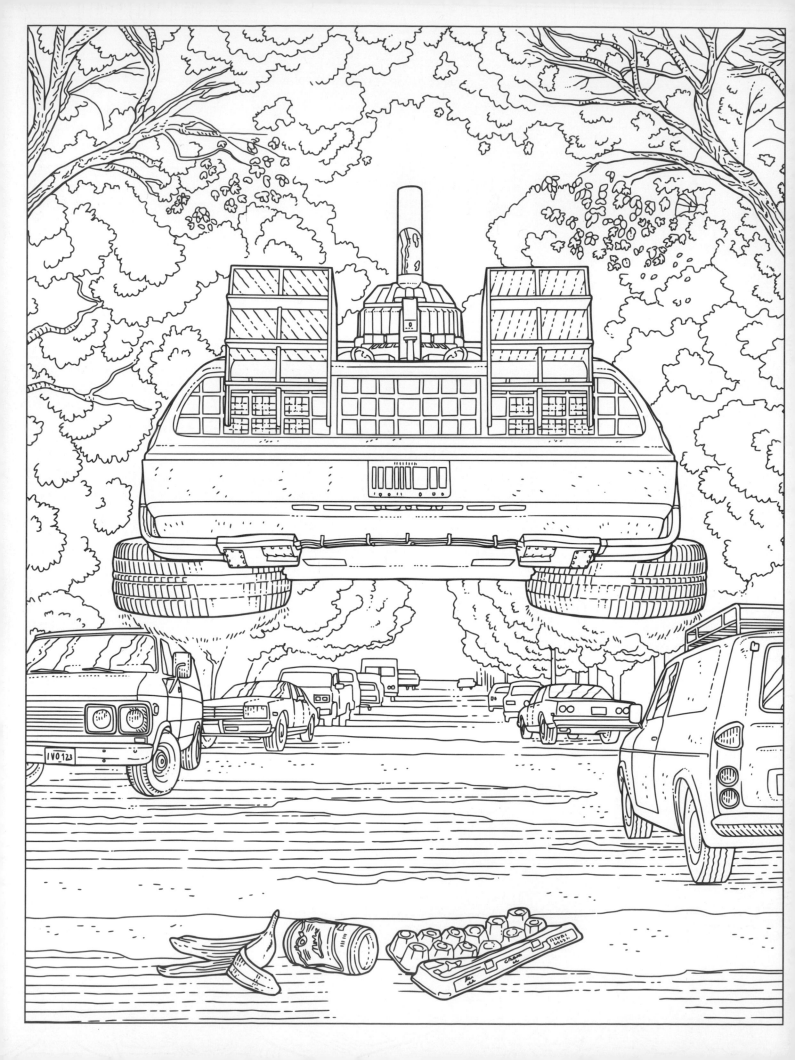

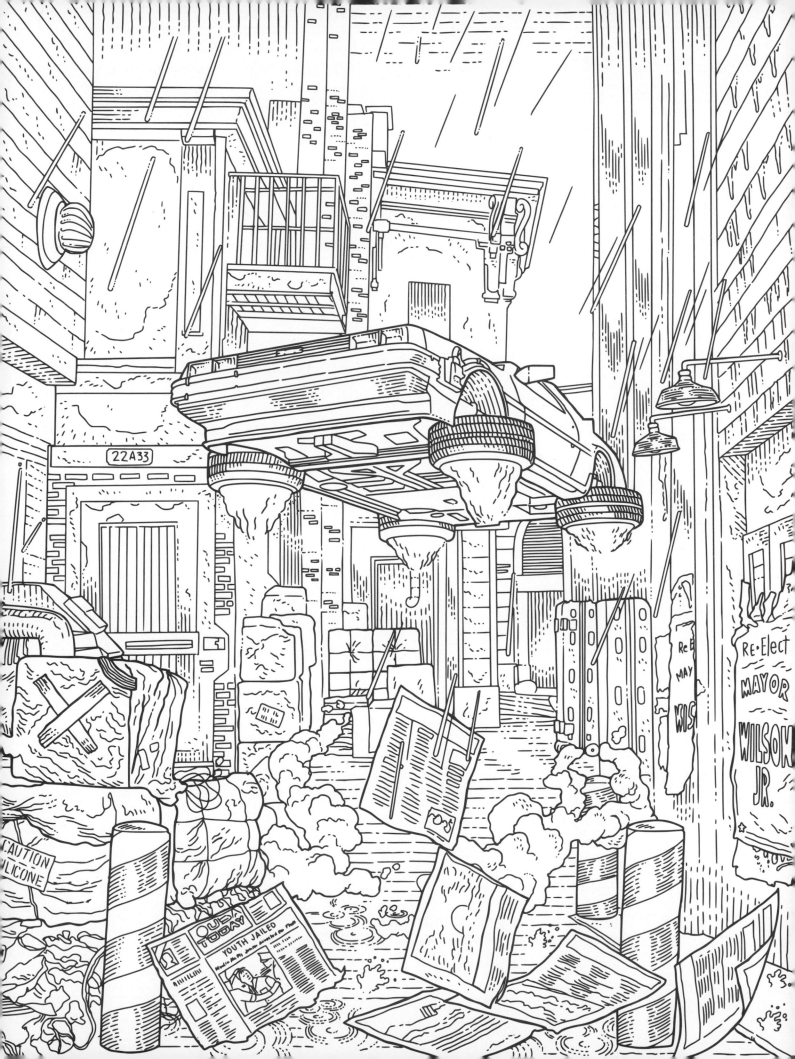

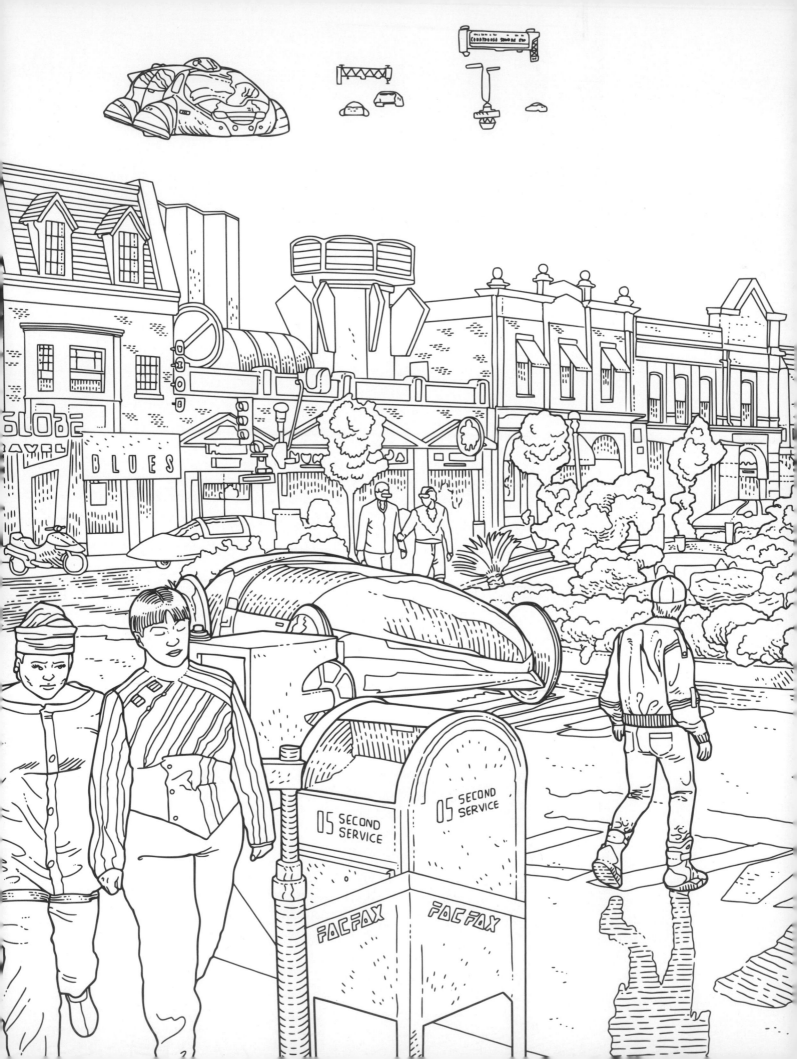

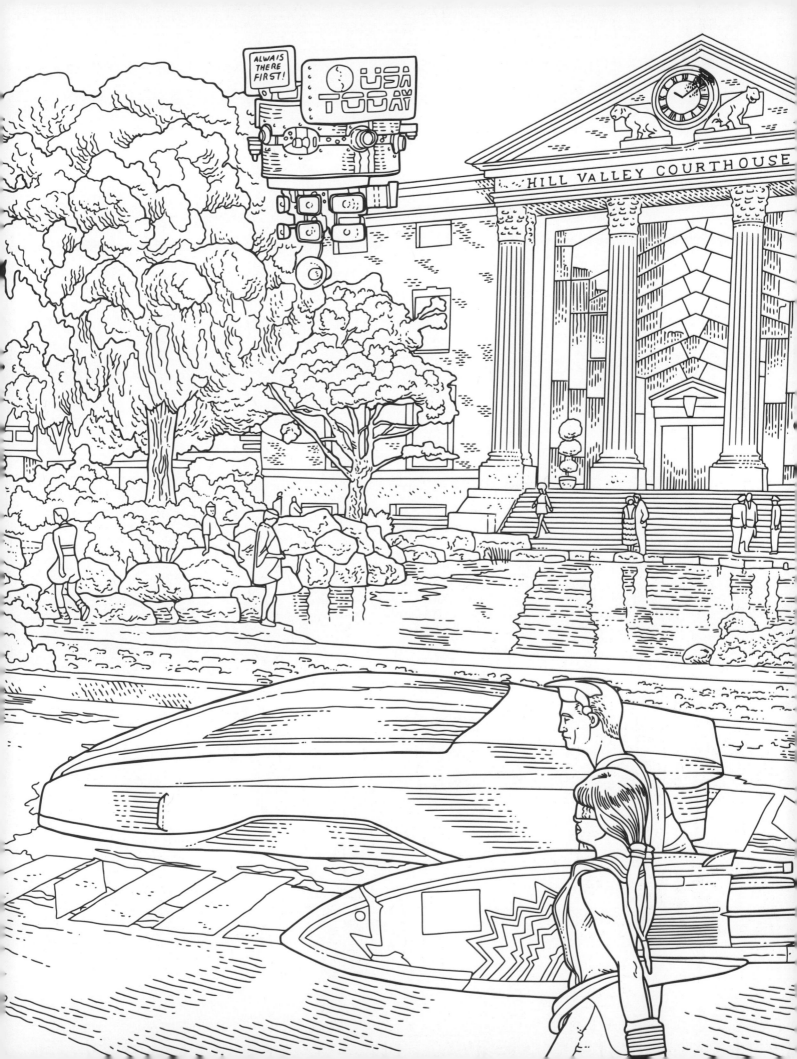

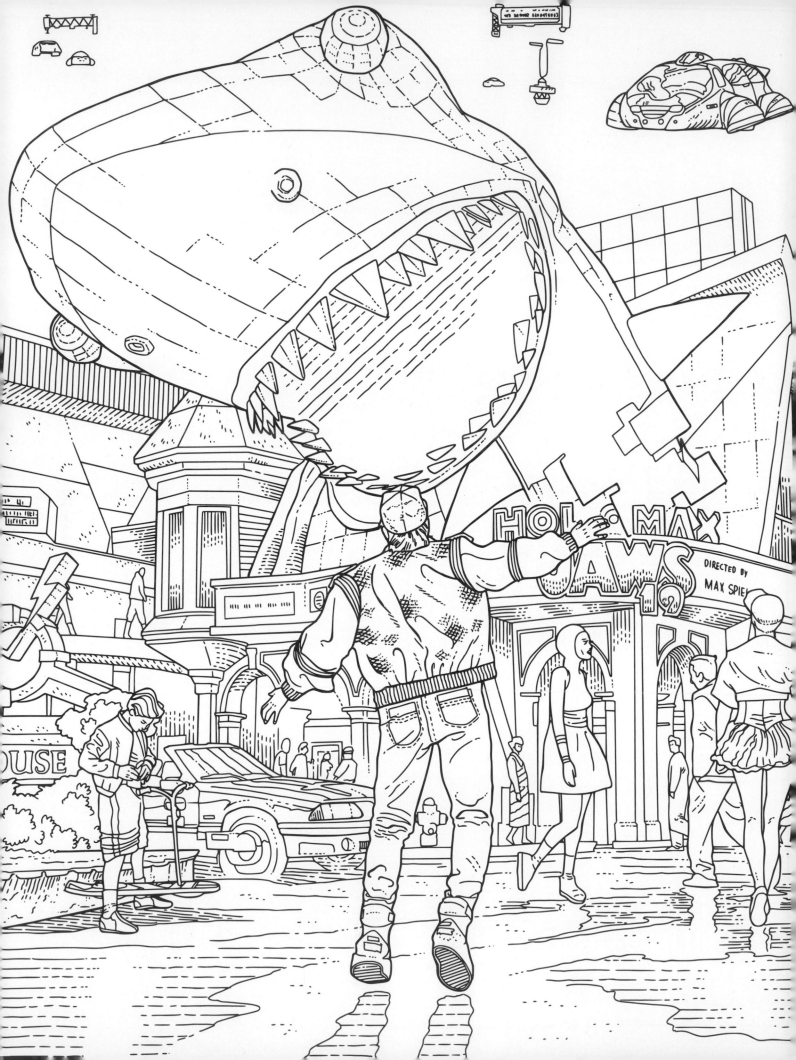

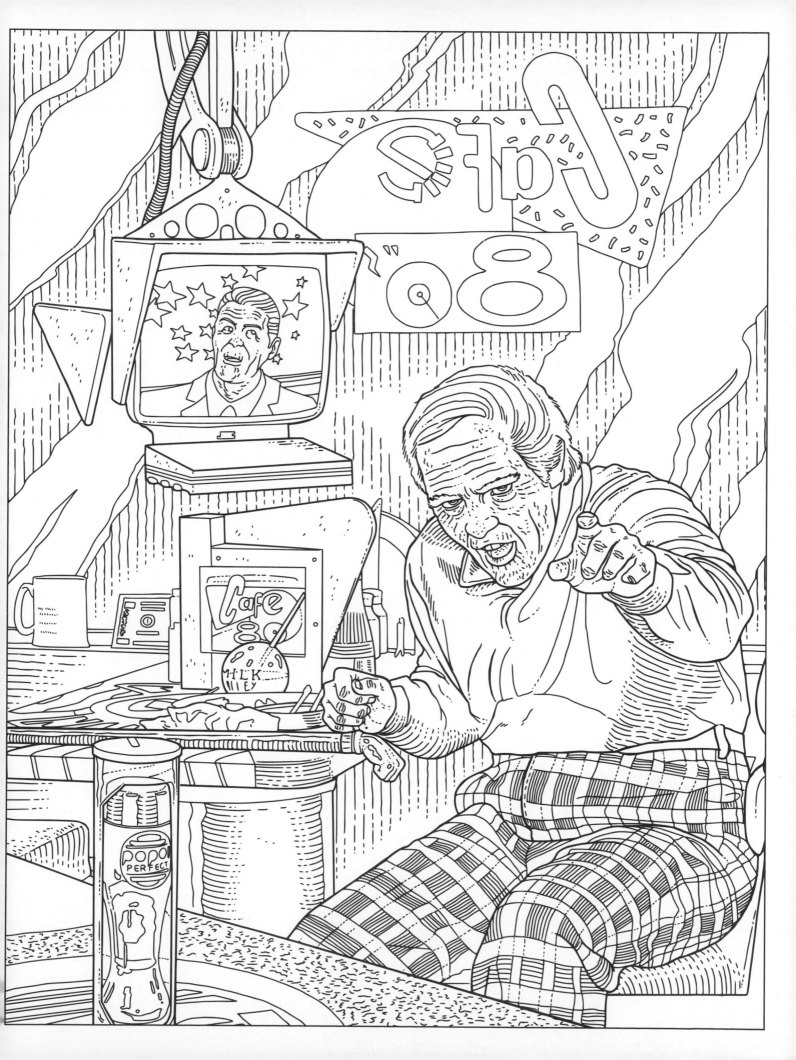

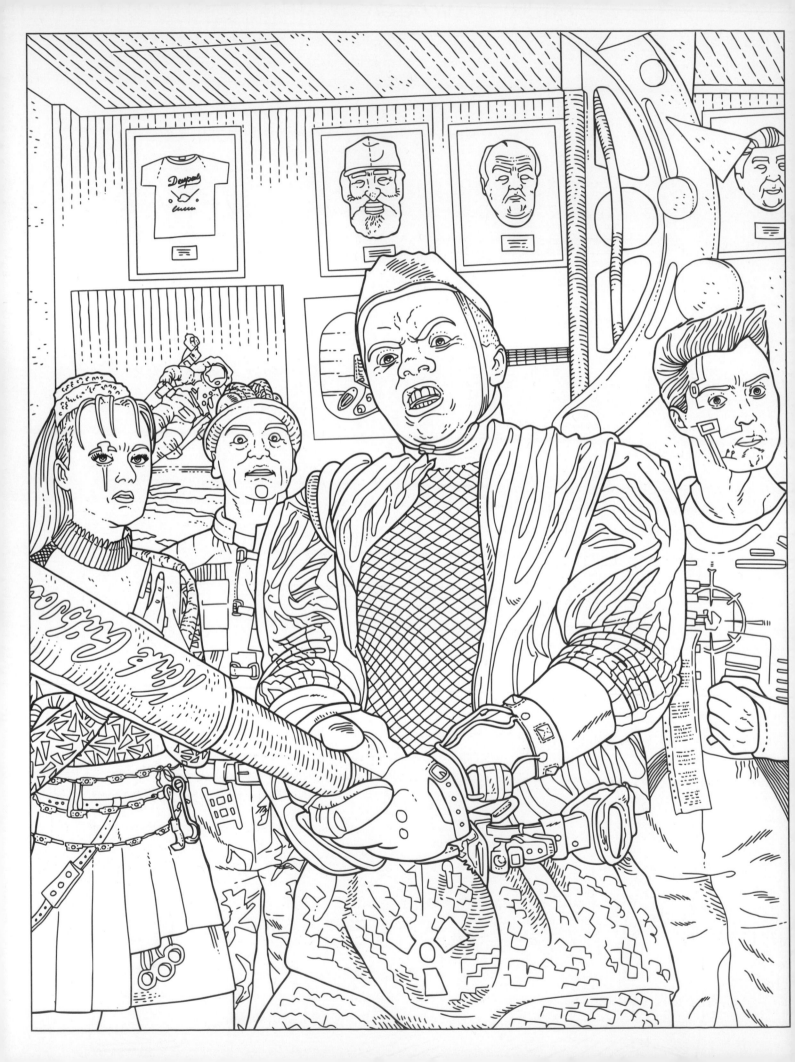

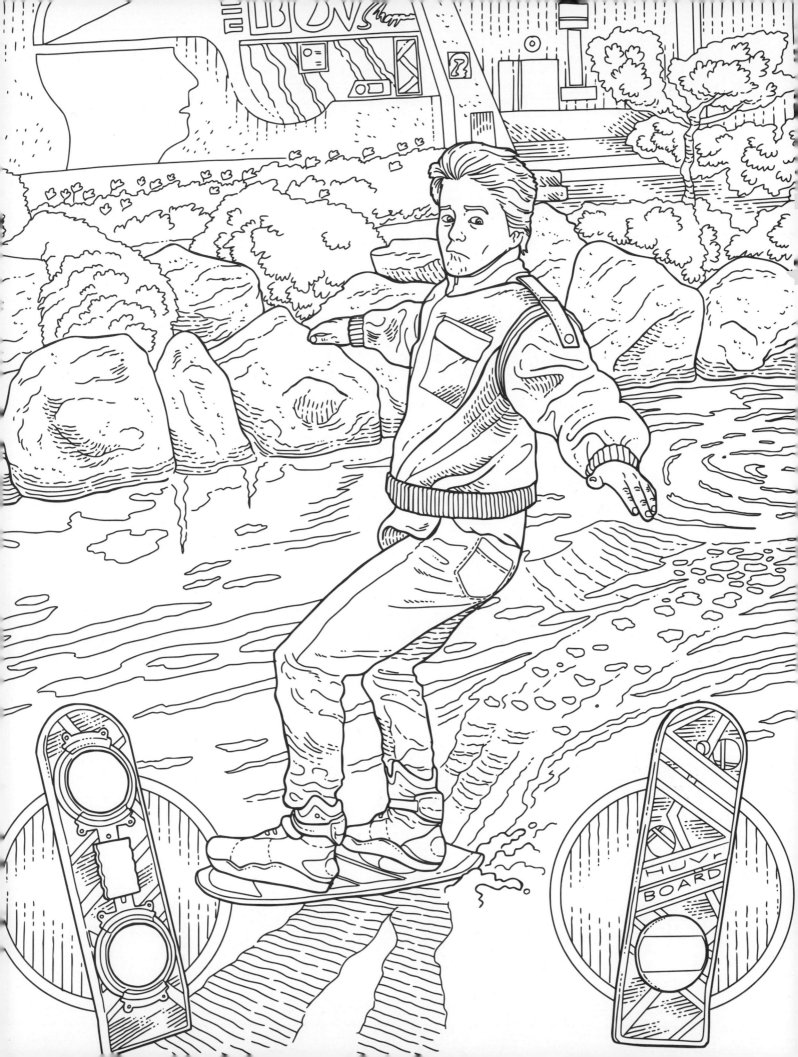

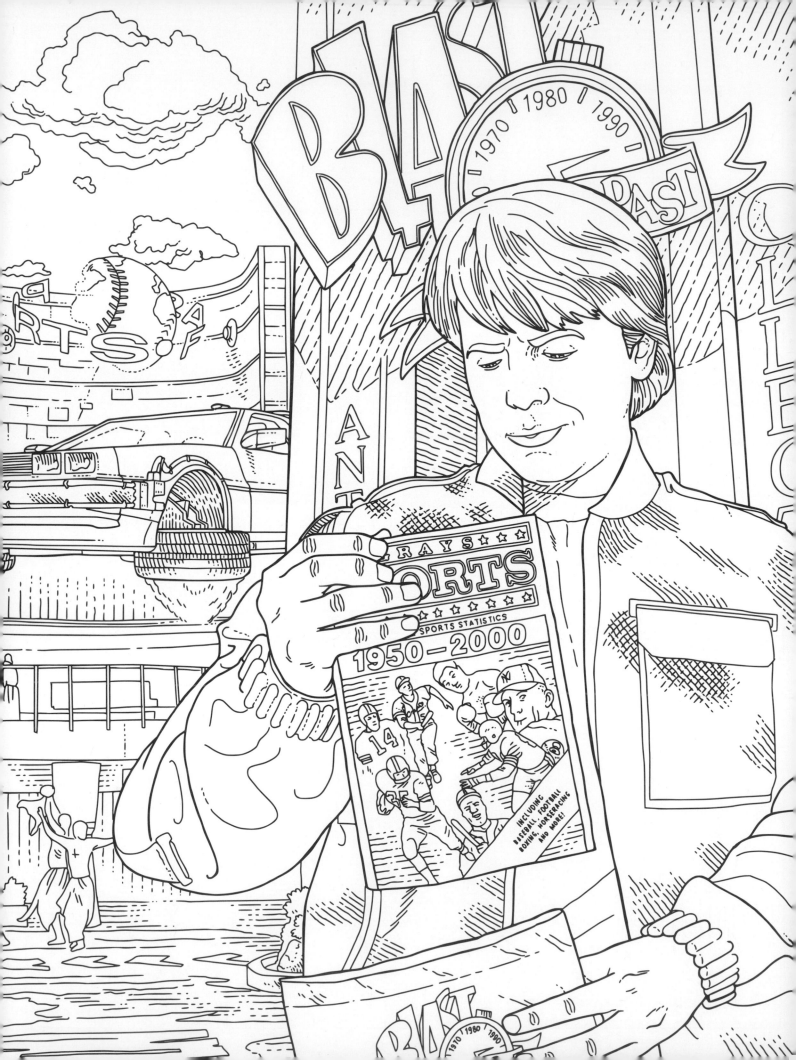

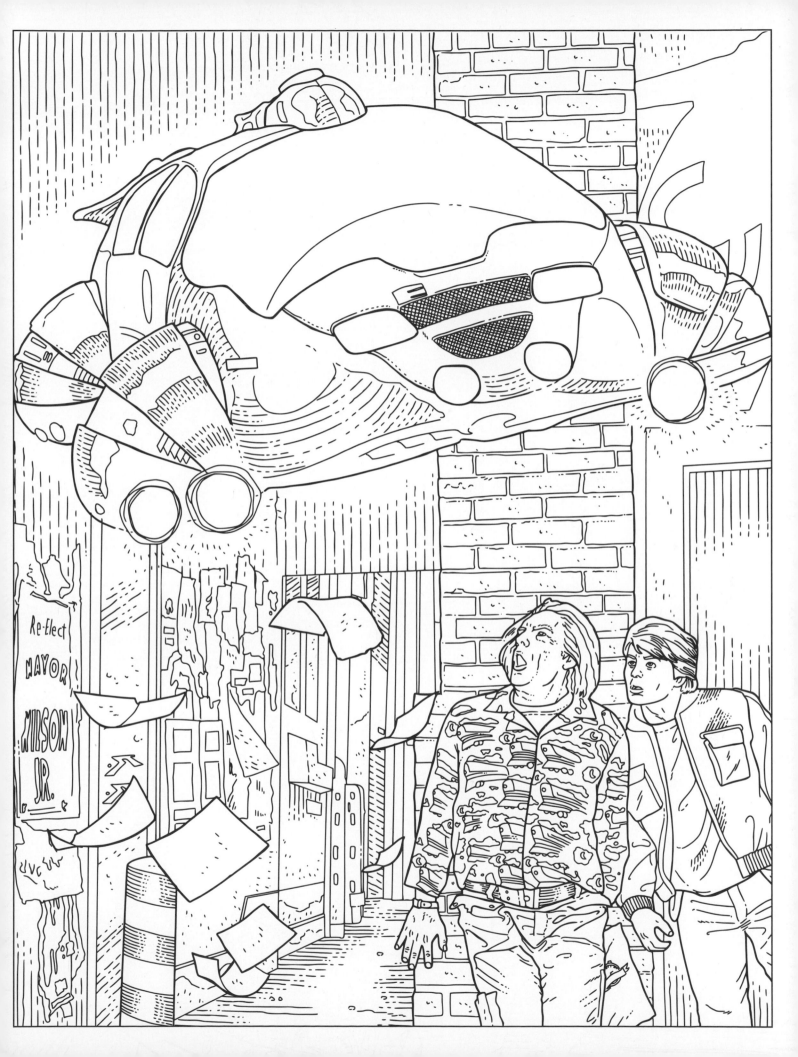

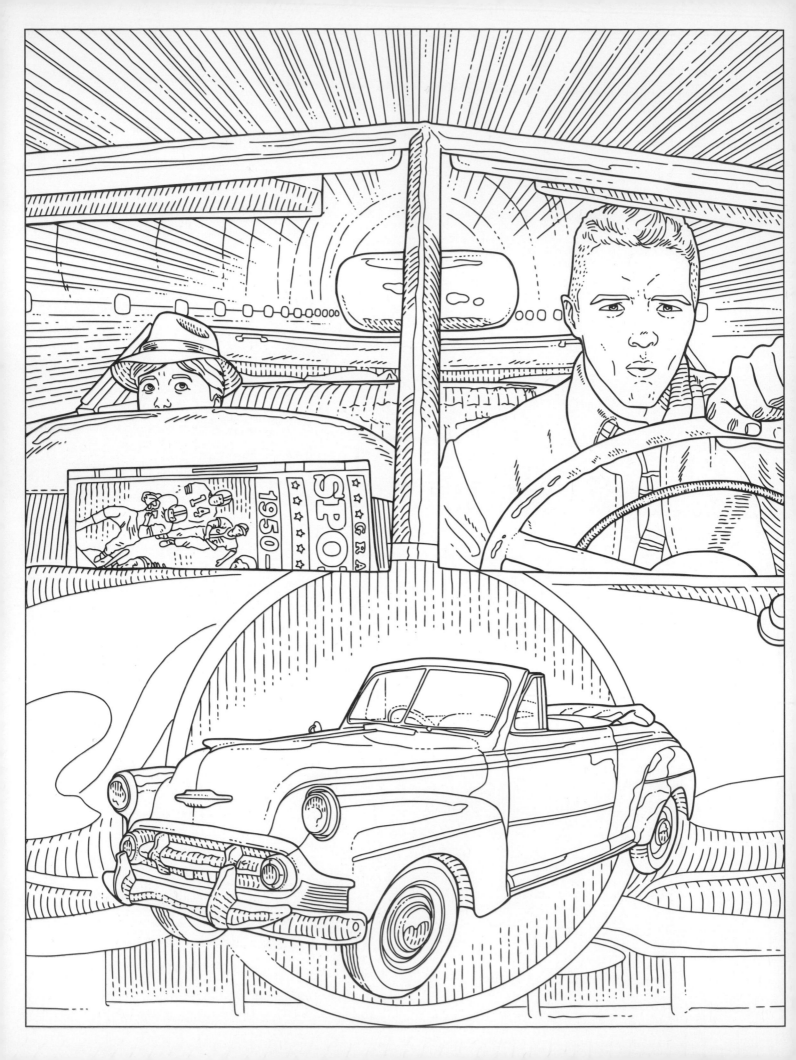

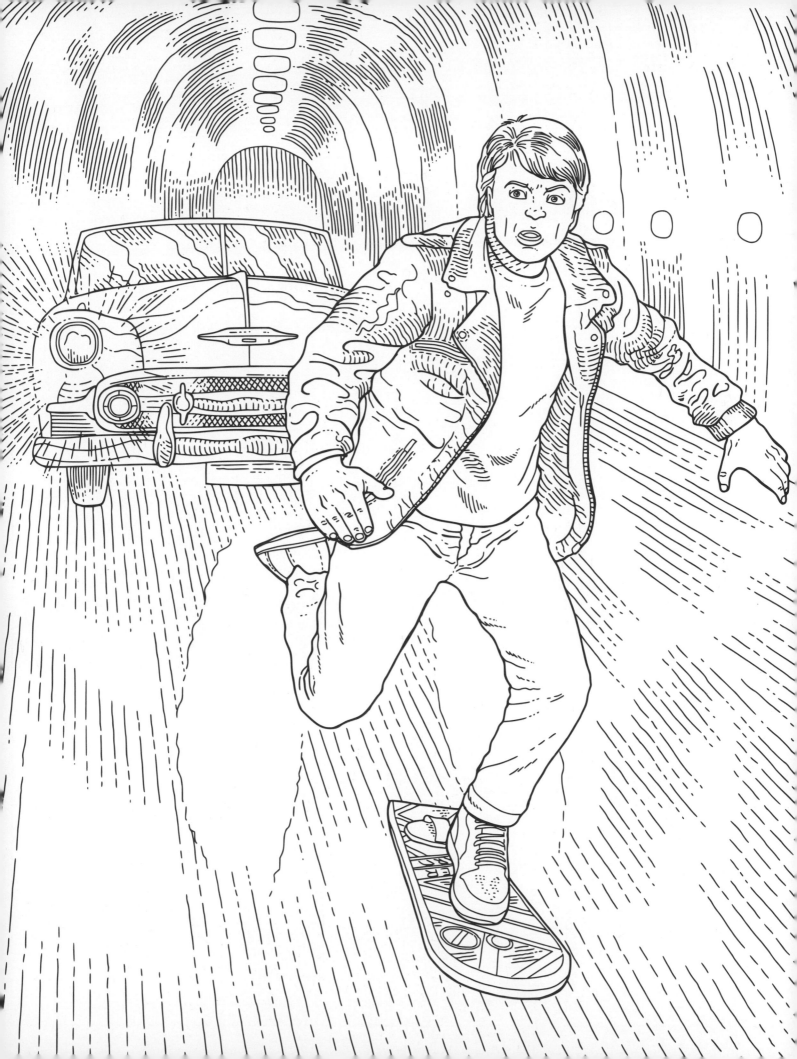

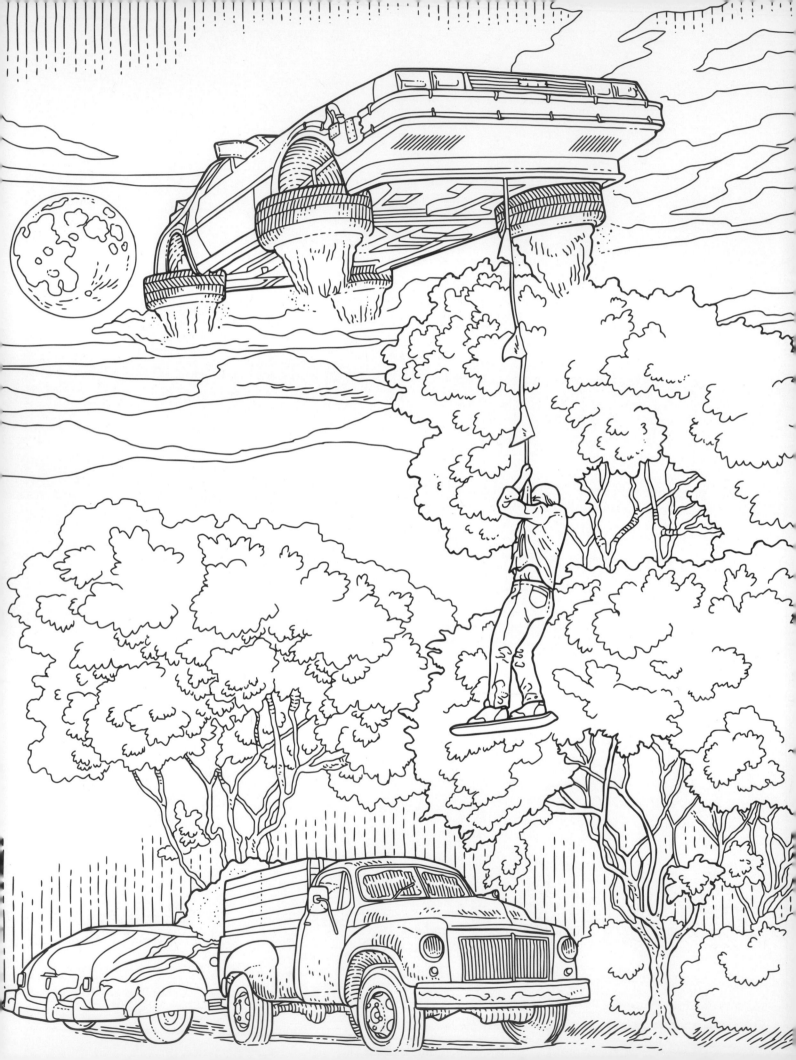

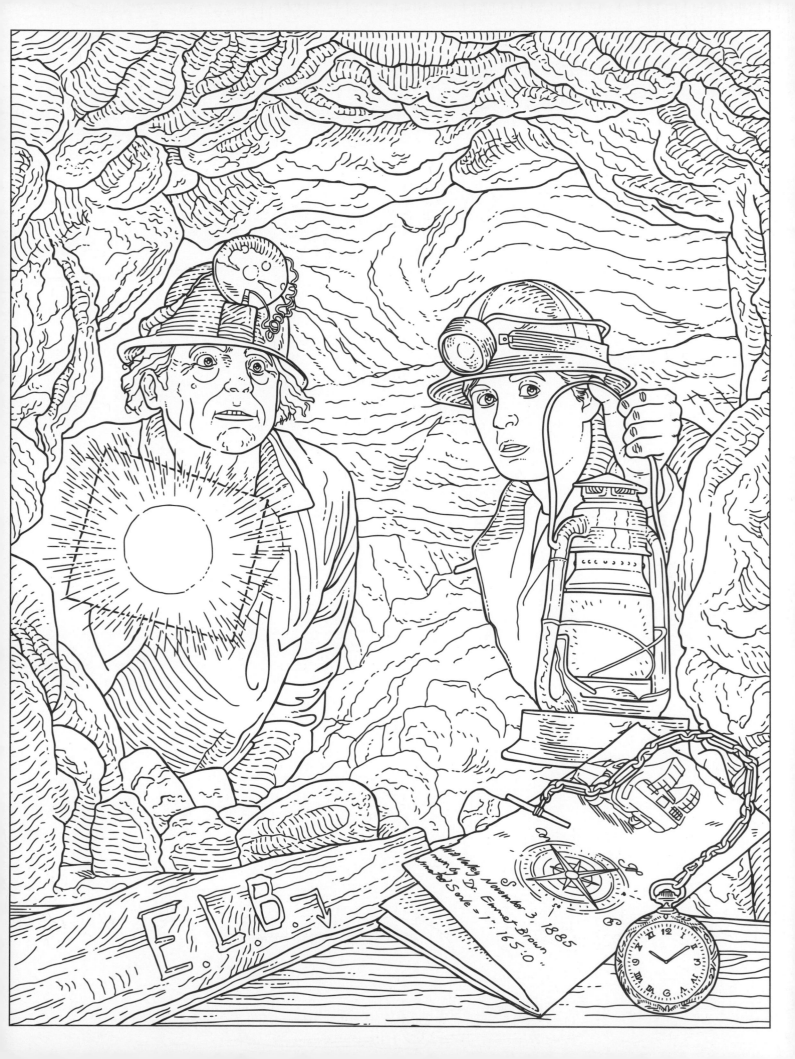

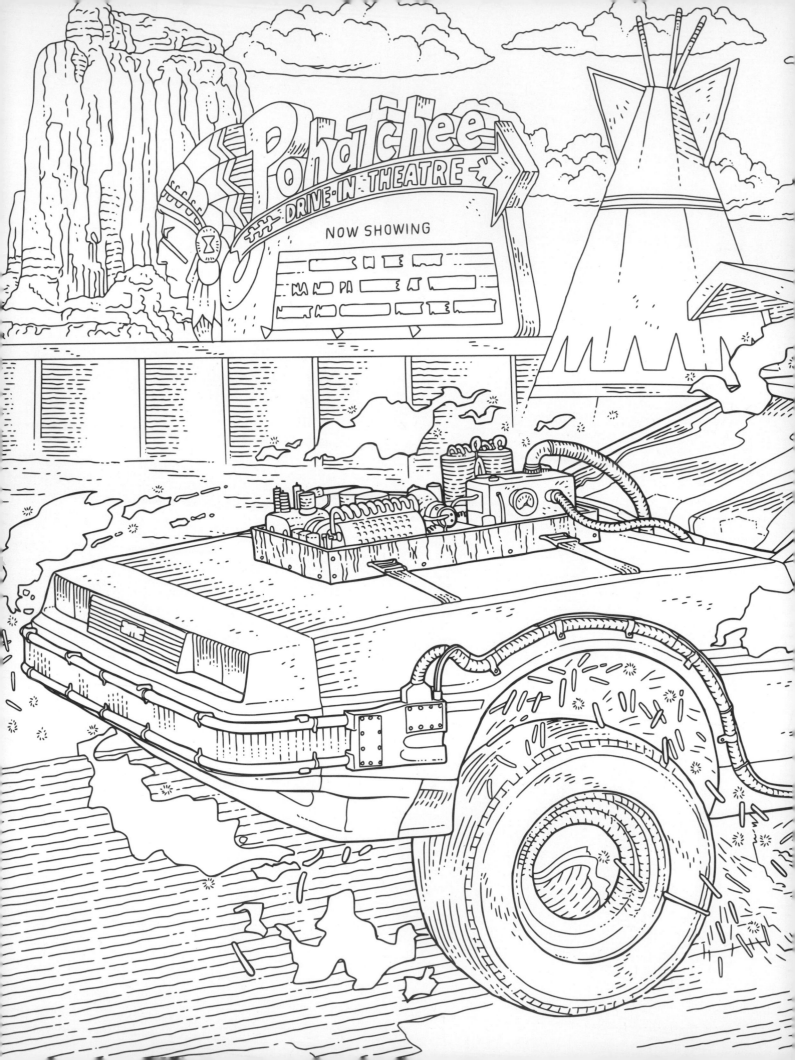

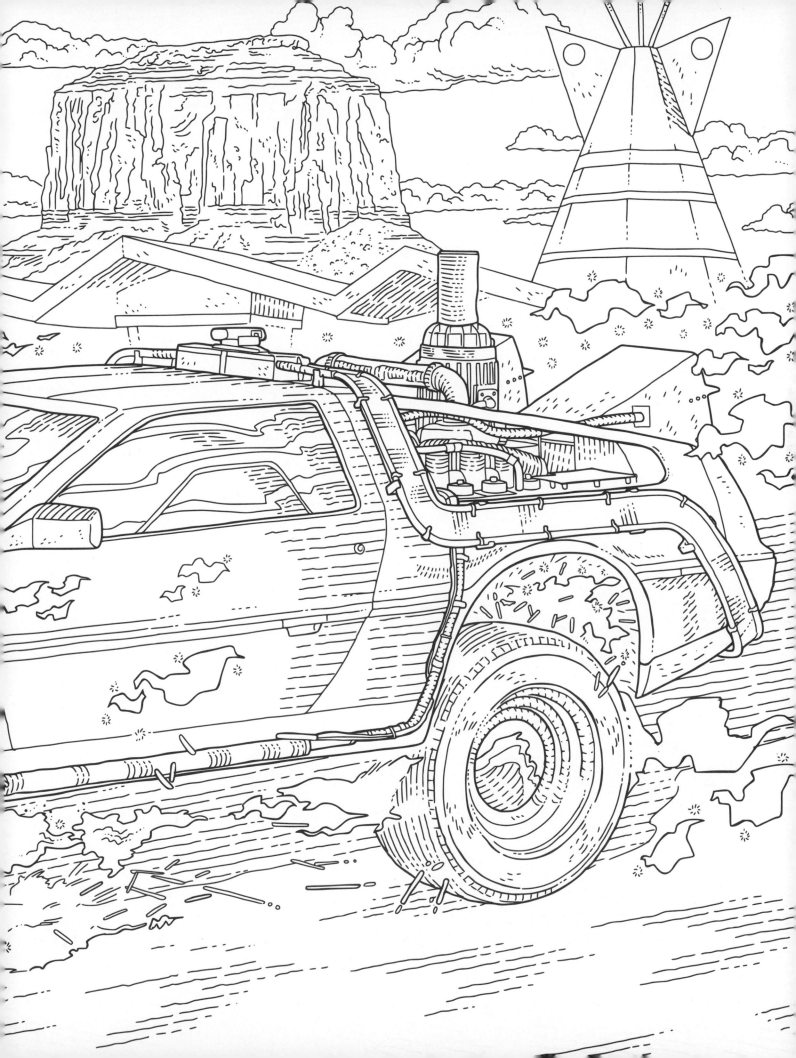

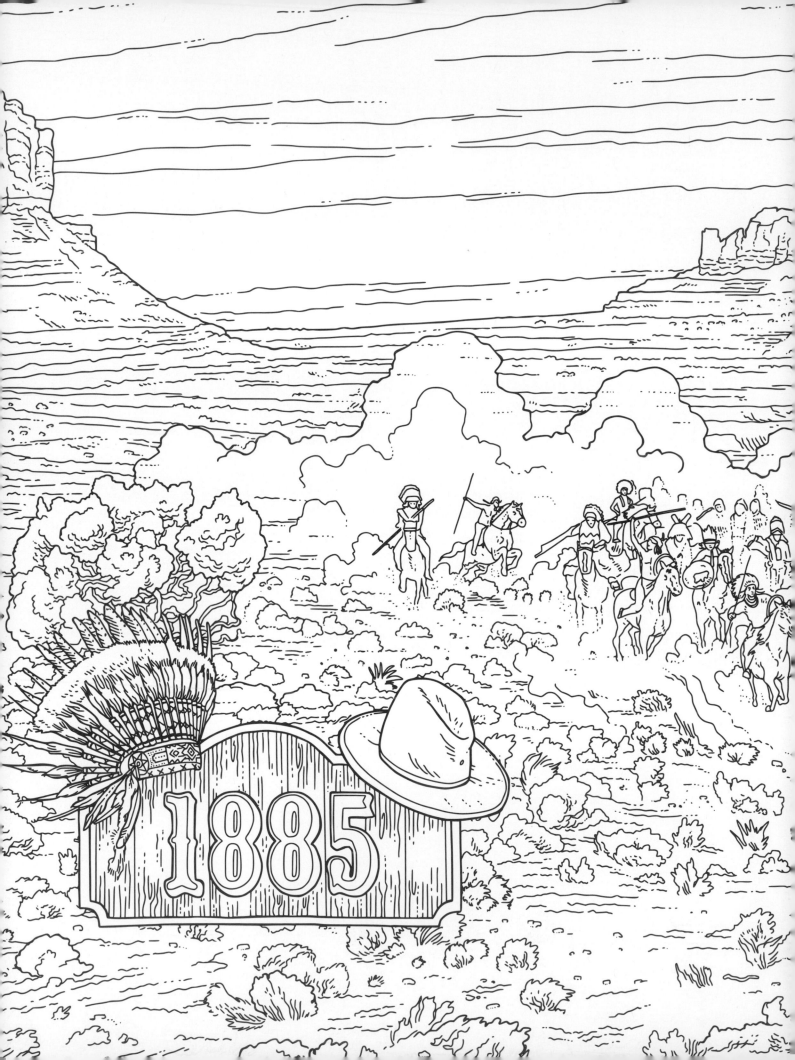

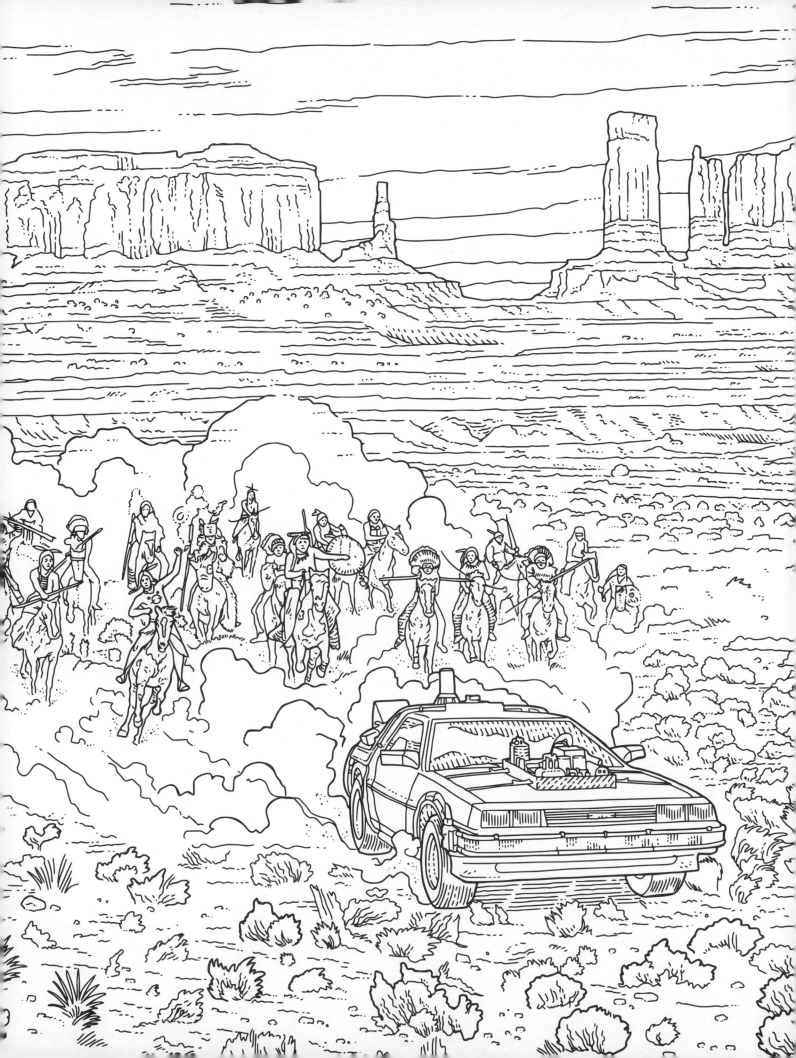

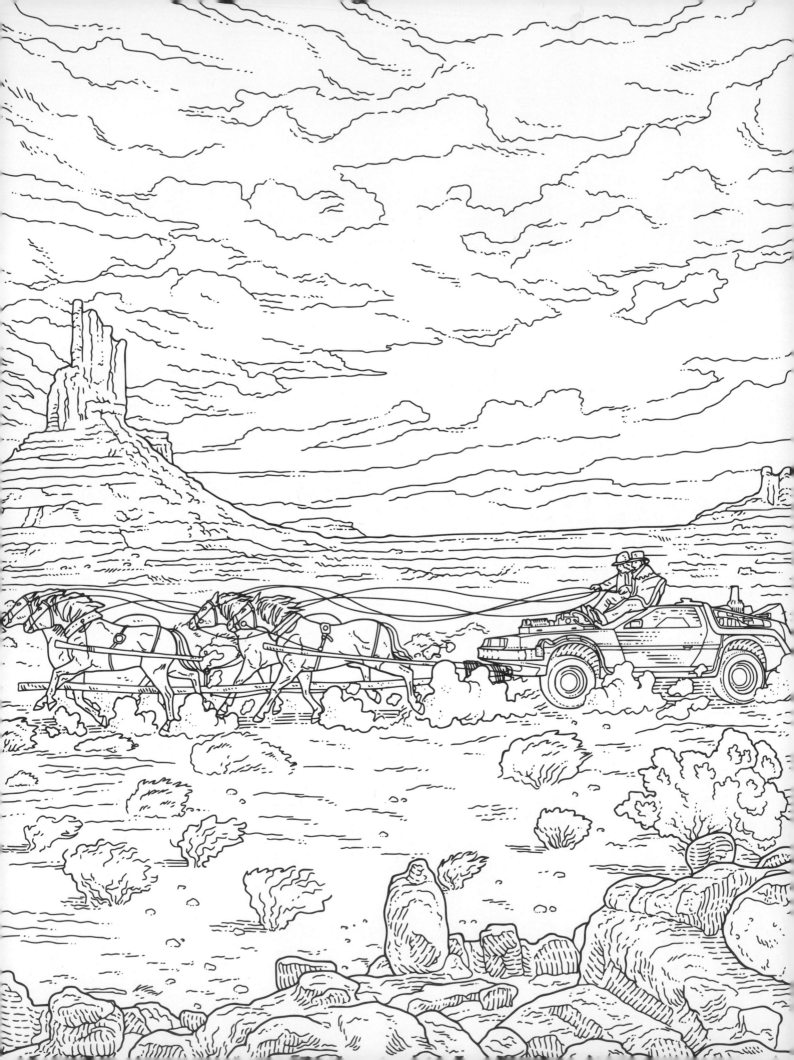

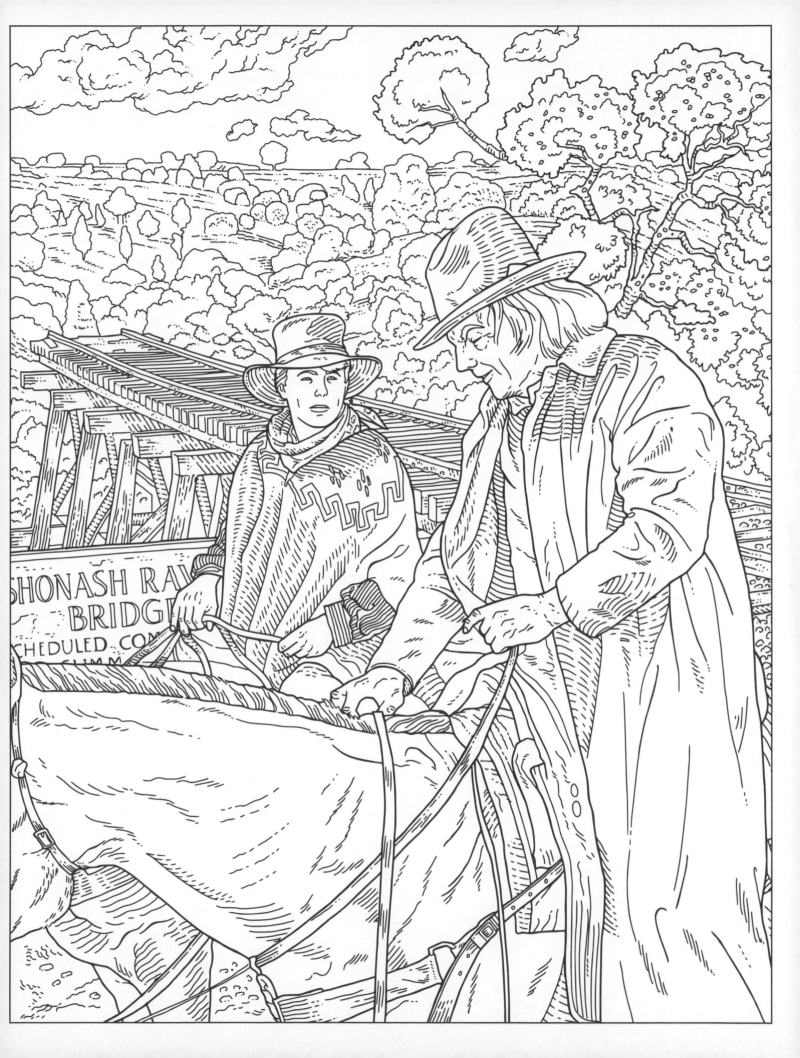

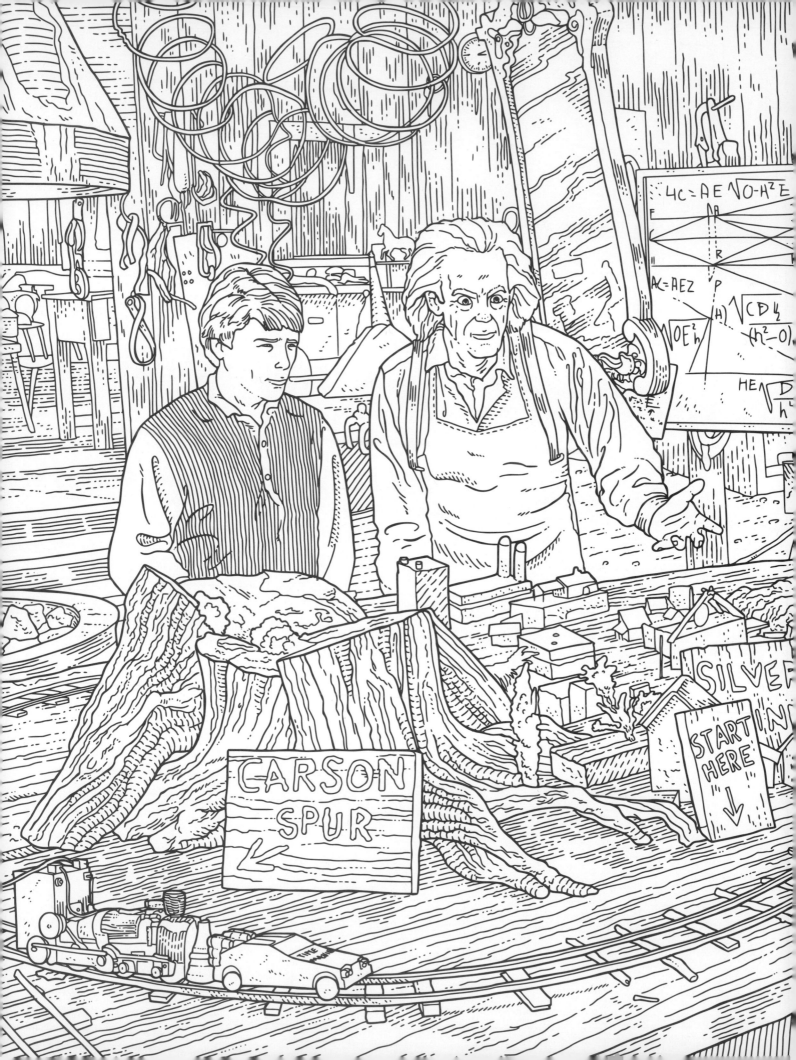

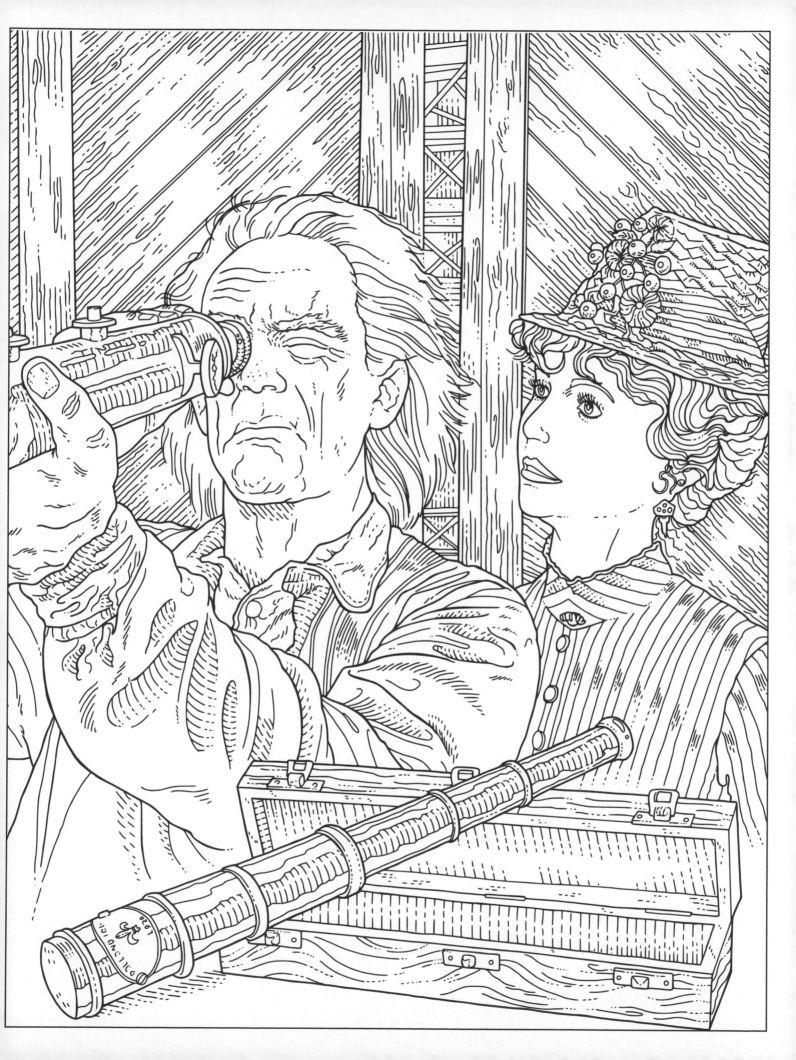

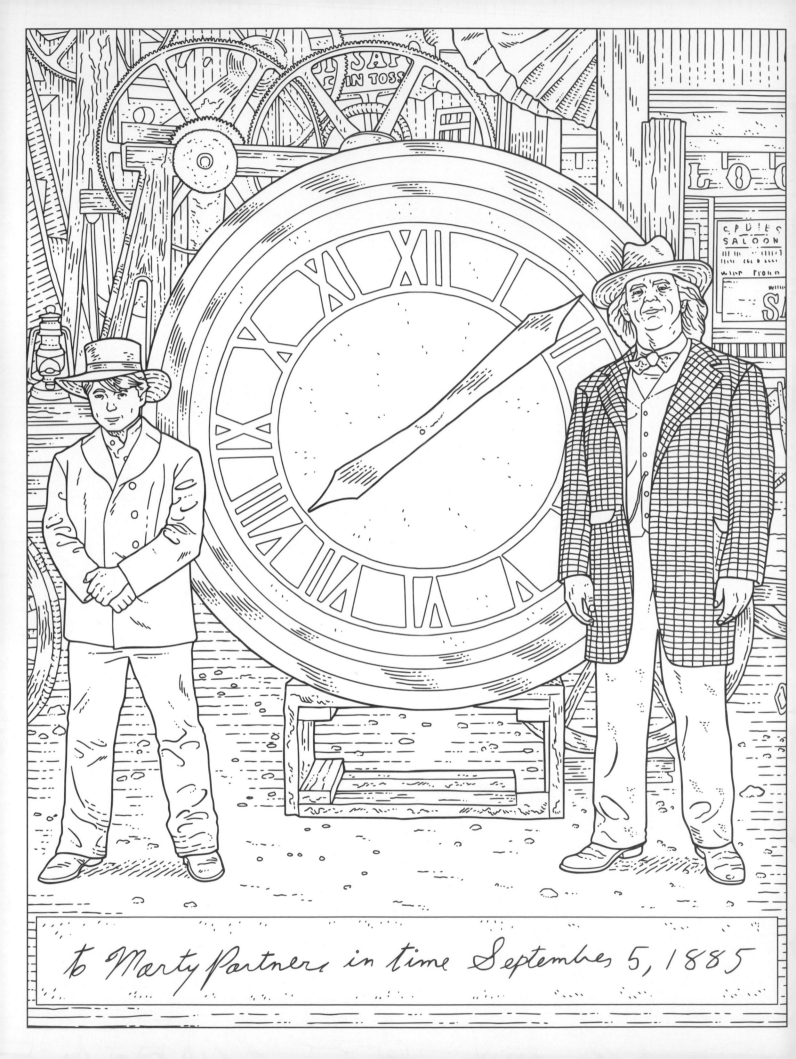

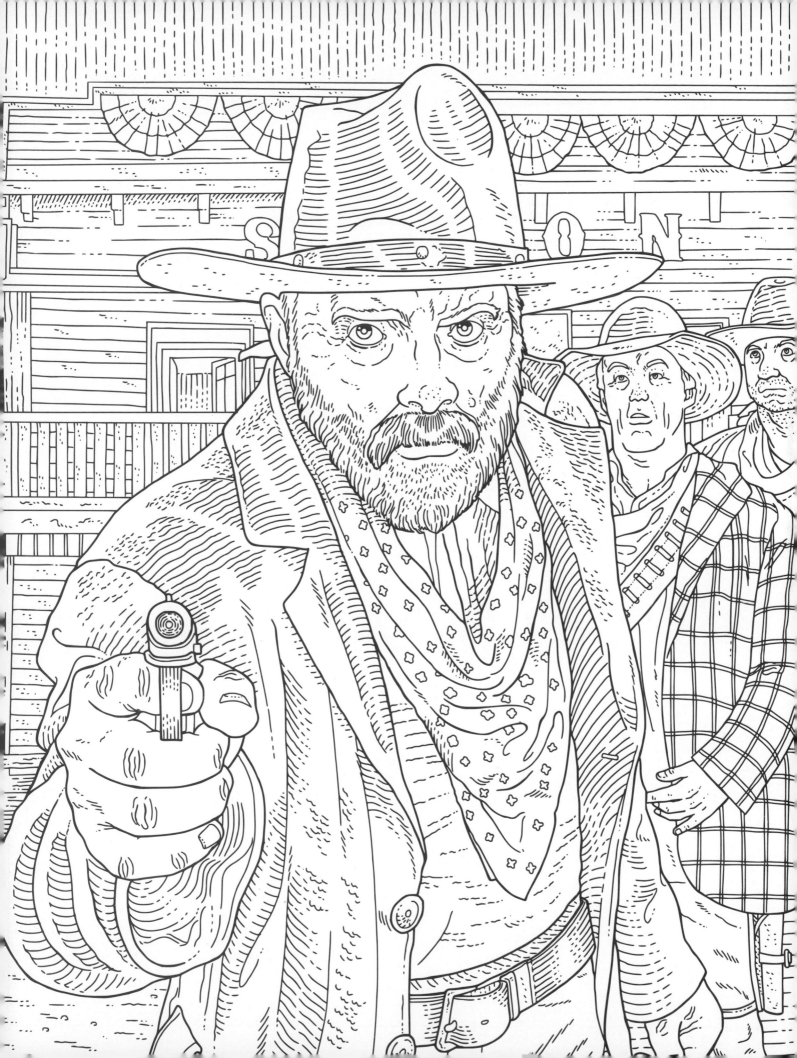

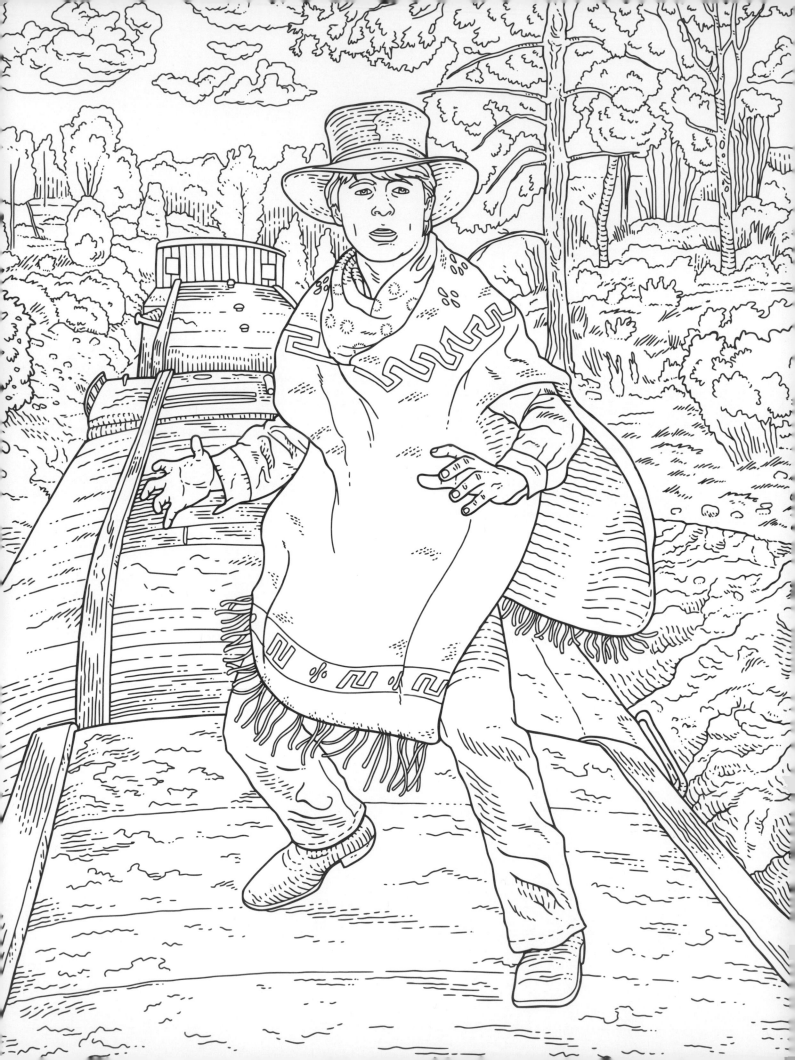

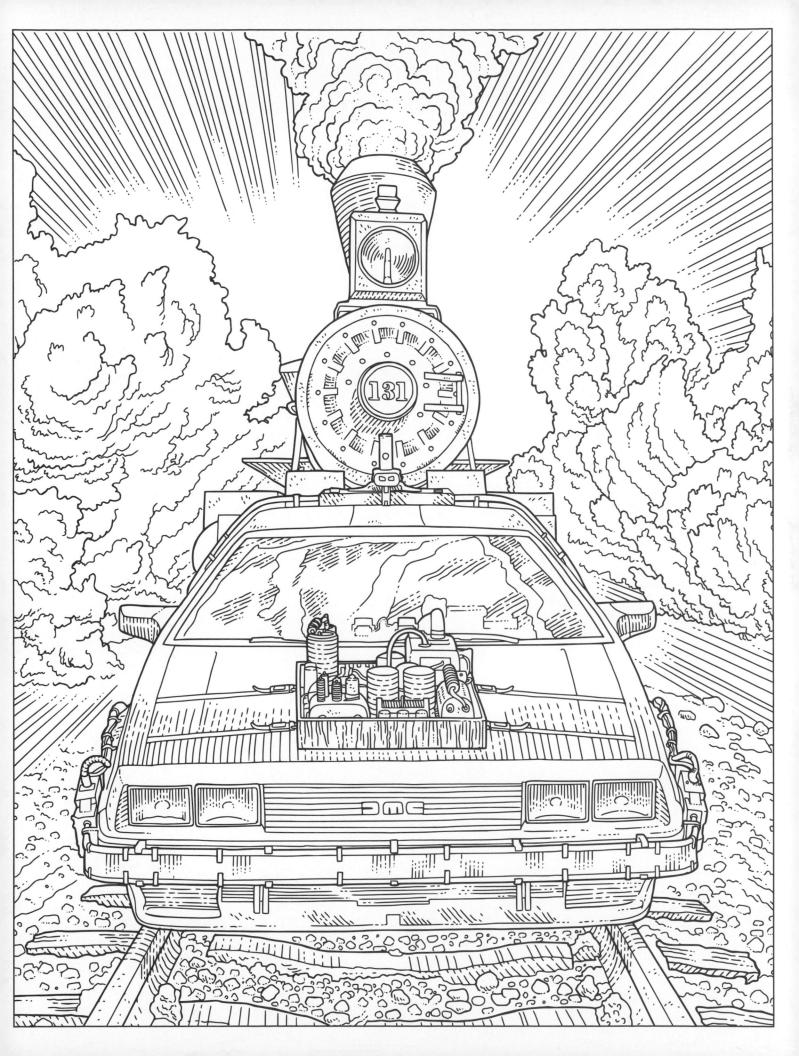

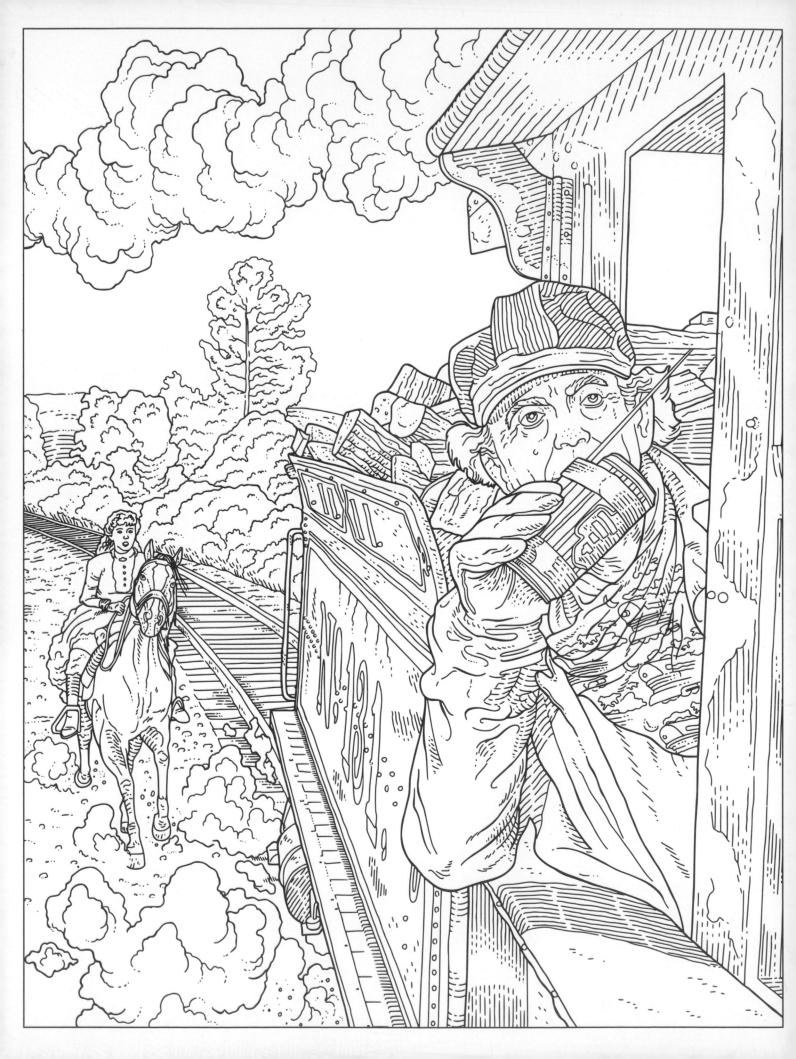

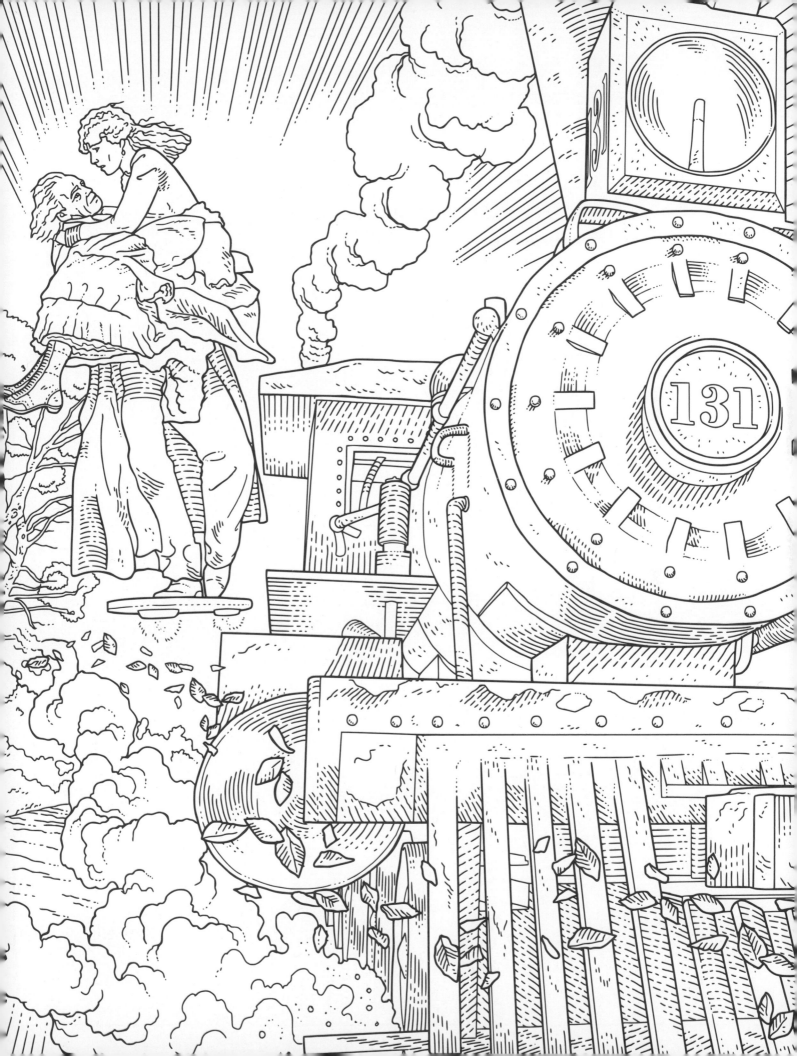

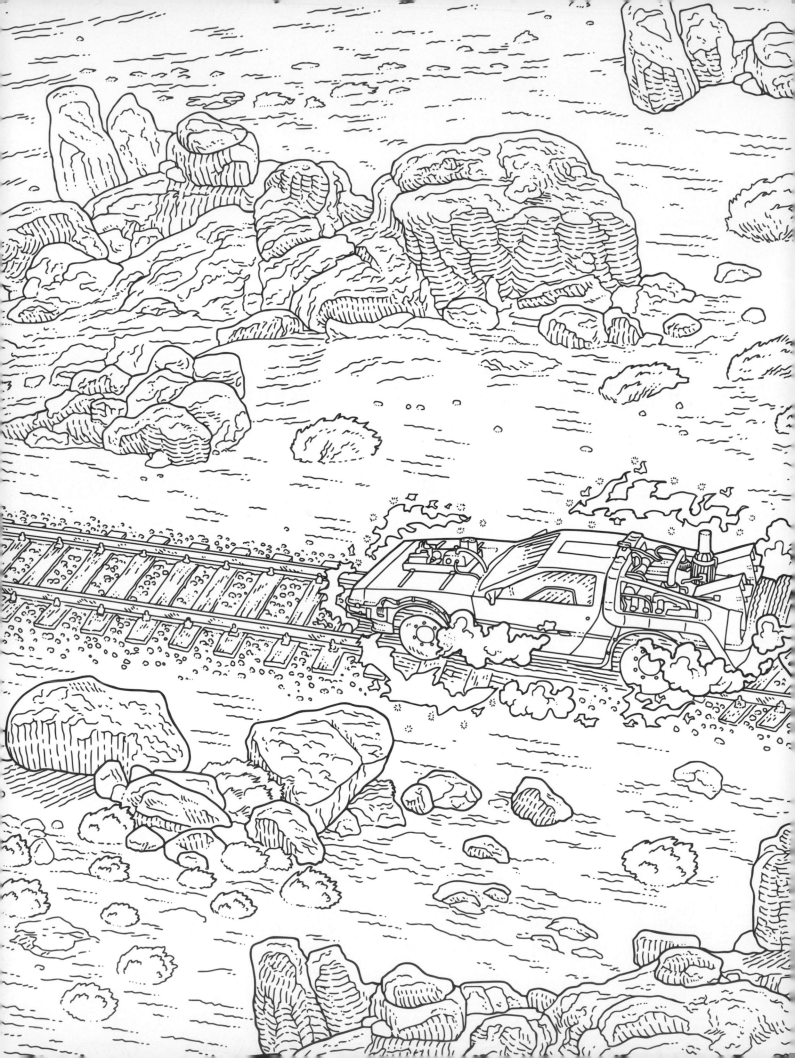

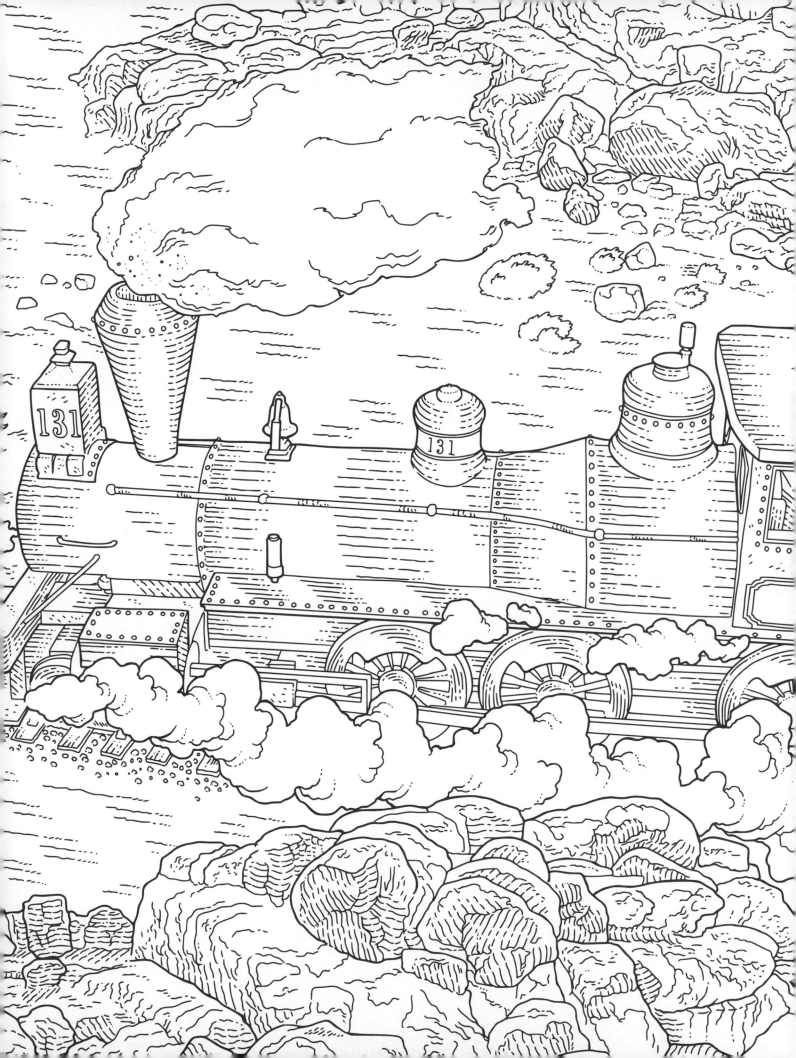

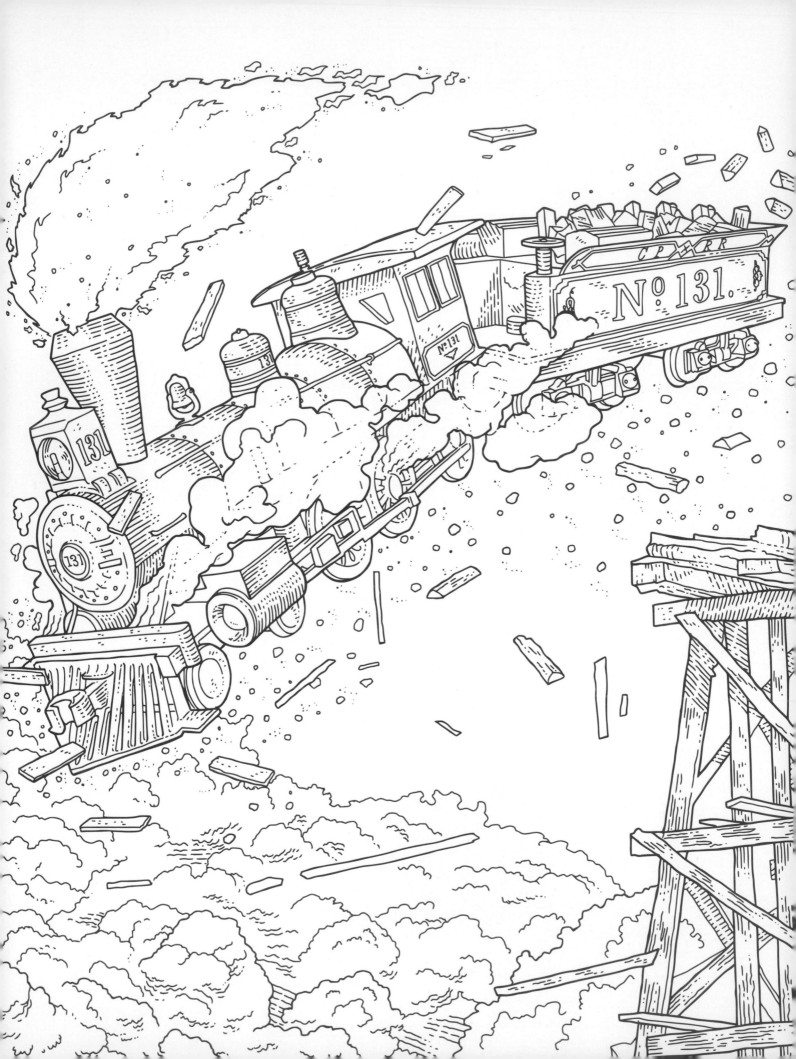

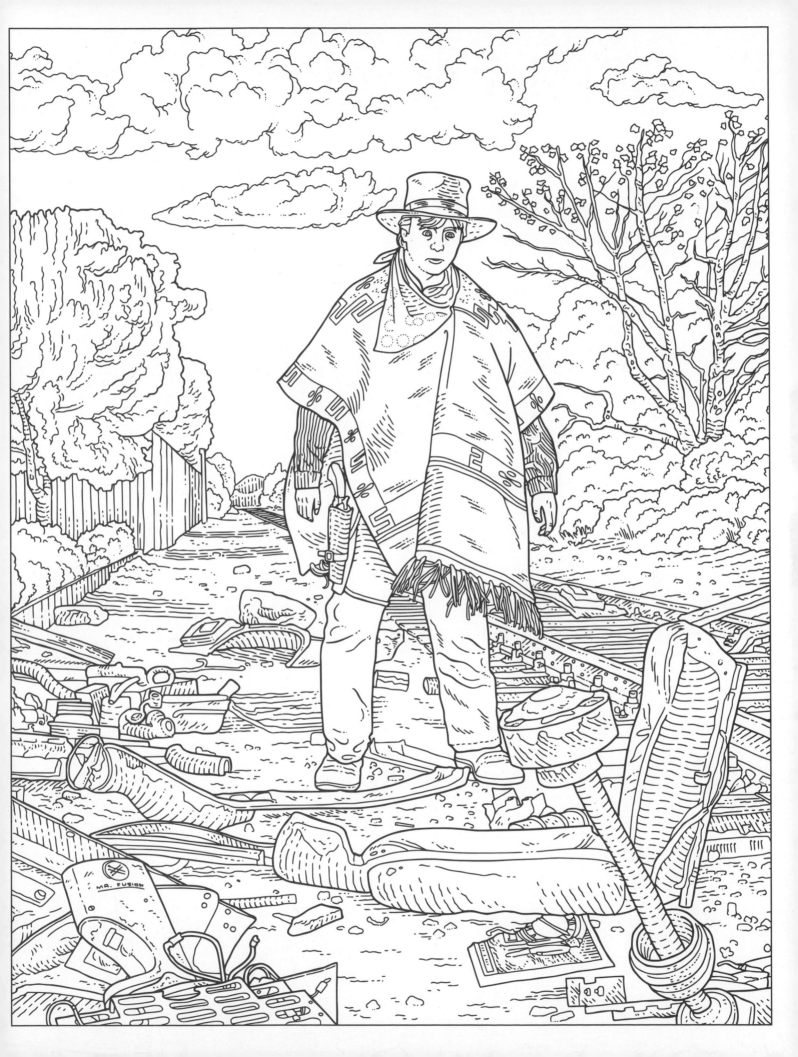

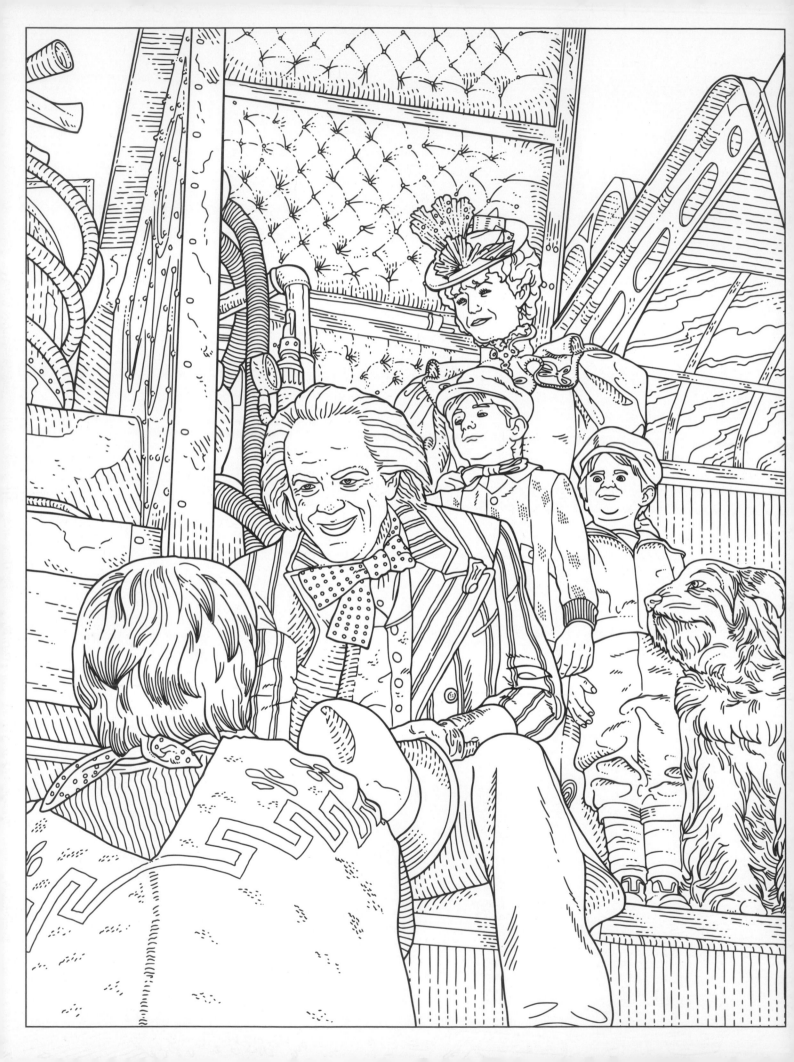

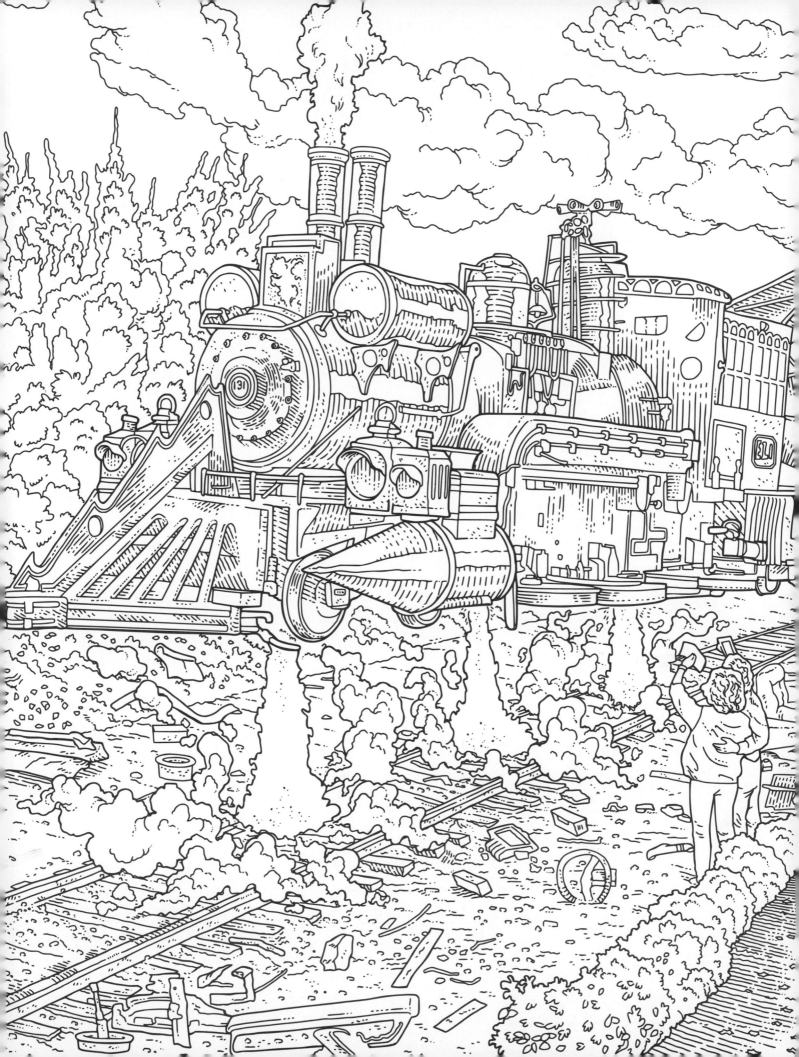

INSIGHT
EDITIONS

PO Box 3088
San Rafael, CA 94912
www.insighteditions.com

Find us on Facebook: www.facebook.com/InsightEditions
Follow us on Twitter: @insighteditions
Follow us on Instagram: @insighteditions

ISBN: 979-8-88663-269-9

Publisher: Raoul Goff
VP, Co-Publisher: Vanessa Lopez
VP, Creative: Chrissy Kwasnik
VP, Manufacturing: Alix Nicholaeff
VP, Group Managing Editor: Vicki Jaeger
Publishing Director: Jamie Thompson
Senior Designer: Judy Wiatrek Trum
Editor: Stephen Fall
Editorial Assistant: Jennifer Pellman
Production Editor: Michael Hylton
Production Associate: Tiffani Patterson
Senior Production Manager, Subsidiary Rights: Lina s Palma-Temena

Illustrations by Valentin Ramon

 REPLANTED PAPER

Insight Editions, in association with Roots of Peace, will plant two trees for each tree
used in the manufacturing of this book. Roots of Peace is an internationally renowned
humanitarian organization dedicated to eradicating land mines worldwide and converting
war-torn lands into productive farms and wildlife habitats. Roots of Peace will plant two
million fruit and nut trees in Afghanistan and provide farmers there with the skills and
support necessary for sustainable land use.

Manufactured in China by Insight Editions

10 9 8 7 6 5 4 3 2